graphicidea

resource

Joyce Rutter Kaye

ROCKPORT

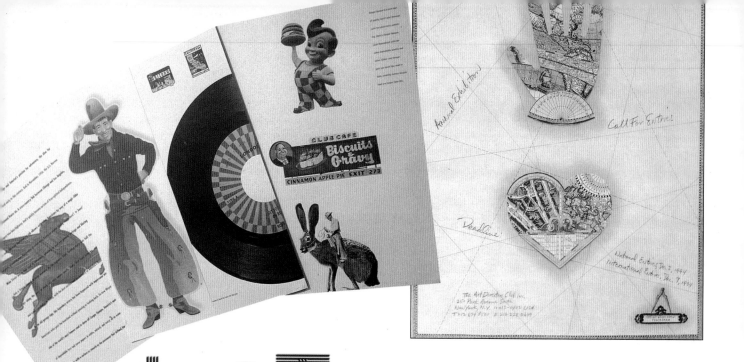

# Layout

. Graphic design is a bit like cooking. When you begin the creative process, you follow a basic structure, using the essential ingredients of type, color, paper, and format, along with a pinch of intuition and a dash of inspiration. You then stir it all together and hope for the best results.

The best graphic design layouts have a balance of flavors that harmonize to create an effective message. Like a great meal, in their ideal form layouts should engage the senses and create an unforgettable moment. The best layouts reveal that the designer trusts his or her instincts to know what is appropriate for the intended audience. Sometimes that means incorporating an element of surprise—using for example, purely type on a brochure to promote a photographer, or photographs of dancers to highlight the elegant lines of a line of eyeglasses. Wit and humor can also be an effective way to engage a consumer's attention, through a clever use of graphic icons to make a visual pun or through deliberately jarring use of contrasting color or type.

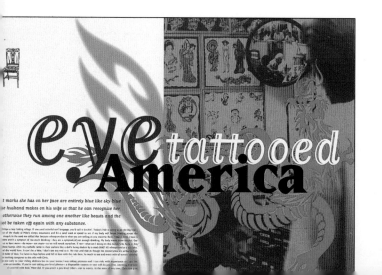

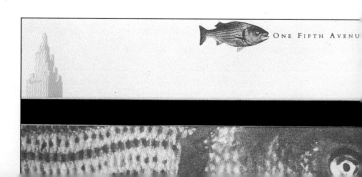

Books are to be returned on or before
the last date below. 741-6

First published in the United States of America by:
Rockport Publishers, Inc.
33 Commercial Street
Gloucester, Massachusetts  01930-5089
Telephone: (978) 282-9590
Facsimile: (978) 283-2742
www.rockpub.com

ISBN 1-56496-373-X
10 9 8 7 6 5 4 3
Selected and edited by Joyce Rutter Kaye
Designer: Monty Lewis

Printed in China.

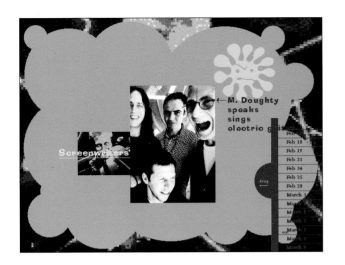

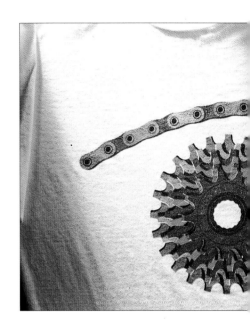

Some designs communicate instantly by their physical form: a flip book to announce a film festival; a die-cut moving announcement that tilts forward, a dinner party invitation that unfolds like a napkin. Other layout designs are remarkable for their simplicity and subtlety: a catalog spread for a furniture company with beautifully lit photos and elegant type, or a menu with soft woodcut illustrations.

The elements of layout design can be taught. However, good layouts become great when the cook in the kitchen knows how to use fine-quality ingredients, experience, intuition and restraint. This book contains 90 examples for you to sample.

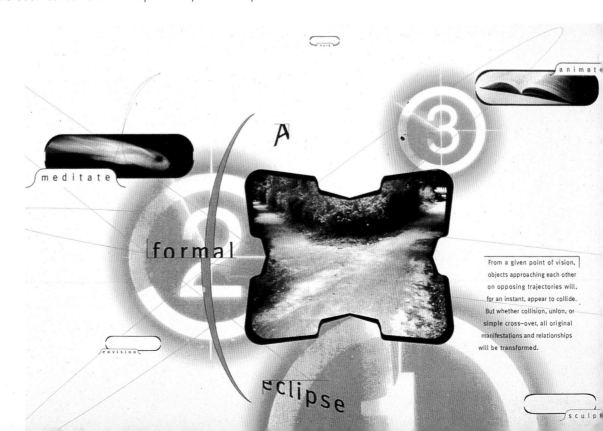

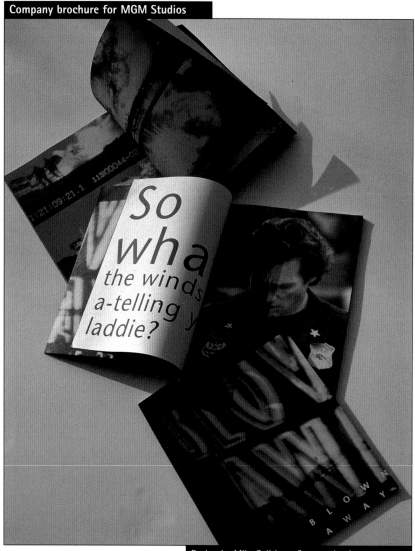

Design by Mike Salisbury Communications
Art Director: Mike Salisbury
Designers: Mike Salisbury, Patrick O'Neal
Illustrators: Joel D. Warren, Bruce Birmeliw

This promotional book for entertainment company MGM emulates the
drama of the company's big-screen productions by showing full-page stills
from action films combined with lines of dialogue in provocative, large-
scale type.

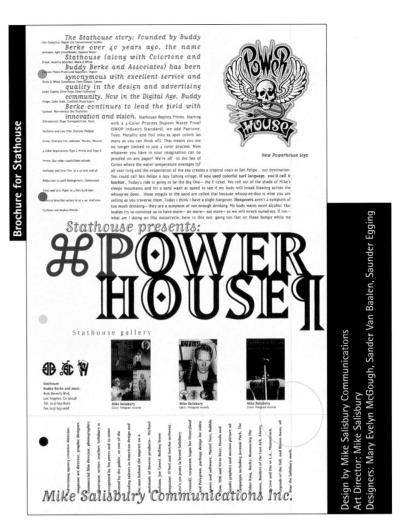

Design by Mike Salisbury Communications
Art Director: Mike Salisbury
Designers: Mary Evelyn McGough, Sander Van Baalen, Saunder Egging

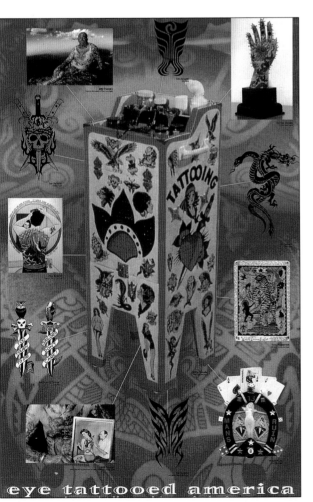

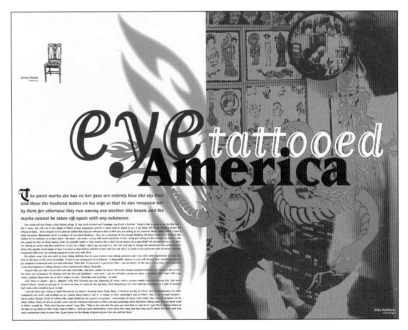

To promote the services of Stathouse, a pre-press service bureau, Mike Salisbury Communications created a brochure that uses striking graphics based on tattoo designs to convey a message about the company's precision color and state-of-the-art digital capabilities.

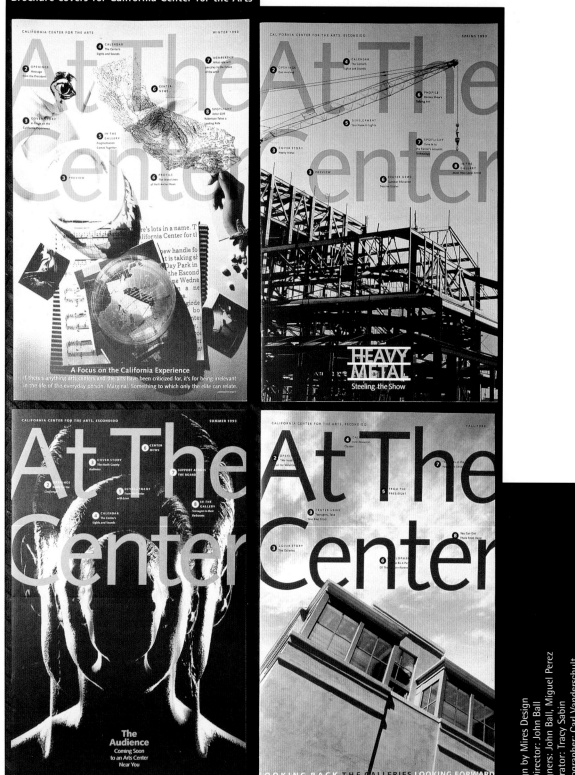

Design by Mires Design
Art Director: John Ball
Designers: John Ball, Miguel Perez
Illustrator: Tracy Sabin
Photographer: Carl Vanderschult

Cover layouts for *At the Center*, a quarterly magazine published by the California Center for the Arts, consistently feature strong, singular black-and-white images from feature articles with a logo treatment in ITC Officina that changes color from issue to issue. The table of contents is sprinkled over the logo treatment, communicating at a glance what is served up inside.

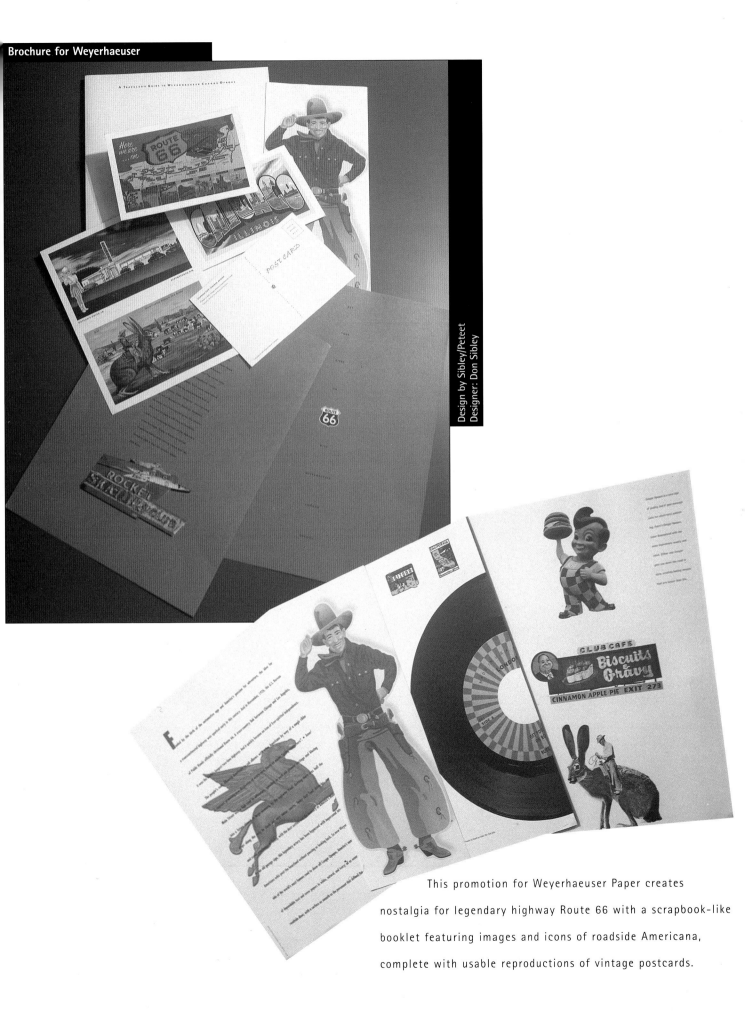

Design by Sibley/Peteet
Designer: Don Sibley

This promotion for Weyerhaeuser Paper creates
nostalgia for legendary highway Route 66 with a scrapbook-like
booklet featuring images and icons of roadside Americana,
complete with usable reproductions of vintage postcards.

The following text appears on the brochure pages shown:

**What if everyone started baking again?** The world would smell better. More people would get to know their neighbors over coffee and danish. Just one drawback. We'd all need bigger sinks, to handle lots of gigantic pans. Good thing we've got the Palisade. It has one deep bowl to manage almost anything. And the classic, simple design makes it a great choice for older homes. Homes where cinnamon and nutmeg still linger in the air. Of course, there's no reason a condominium can't be like that, too.

palisade

— 10 —

THE KITCHEN BOOK

Design by Carmichael Lynch
Art Director/Designer: Pete Winecke

**Brochure for American Standard**

This brochure for American Standard was created to draw attention to the company's line of kitchen fixtures. Color photographs subtly display how the faucets complement both the beauty and the lifestyle of the households where they are found.

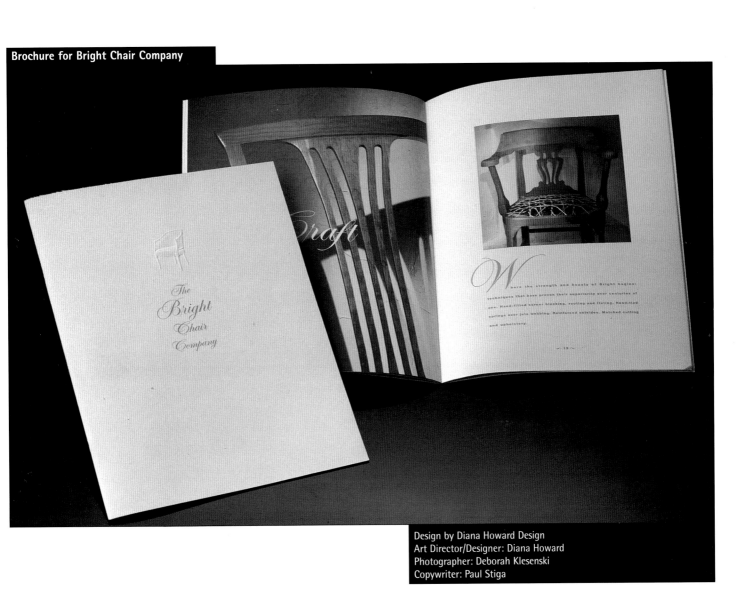

**Brochure for Bright Chair Company**

Design by Diana Howard Design
Art Director/Designer: Diana Howard
Photographer: Deborah Klesenski
Copywriter: Paul Stiga

Spreads in this brochure for the Bright Chair Company

convey old-world craftsmanship through softly lit

photographs of furniture details and the use of a

delicate script for headlines and drop-cap letters.

Ornaments framing folios add a genteel touch.

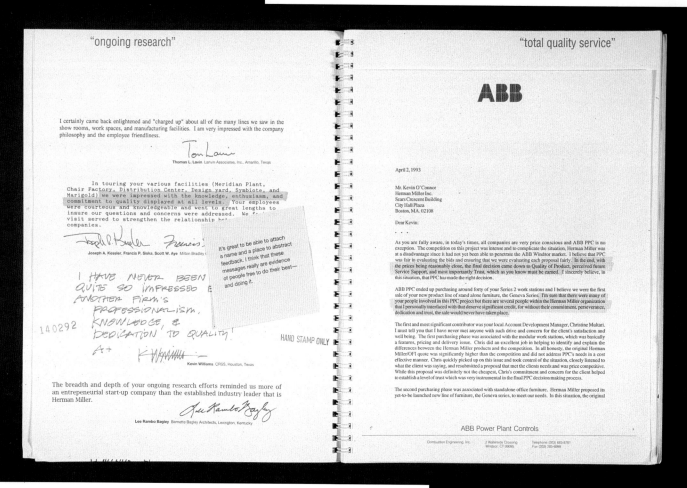

"ongoing research"

"total quality service"

I certainly came back enlightened and "charged up" about all of the many lines we saw in the show rooms, work spaces, and manufacturing facilities. I am very impressed with the company philosophy and the employee friendliness.

*Tom Lavin*

Thomas L. Lavin Lanvin Associates, Inc., Amarillo, Texas

In touring your various facilities (Meridian Plant, Chair Factory, Distribution Center, Design yard, Symbiote, and Marigold) we were impressed with the knowledge, enthusiasm, and commitment to quality displayed at all levels. Your employees were courteous and knowledgeable and went to great lengths to insure our questions and concerns were addressed. We f visit served to strengthen the relationship b+ companies.

Joseph A. Kessler, Francis P. Siska, Scott W. Aye  Milton Bradley (

I HAVE NEVER BEEN QUITE SO IMPRESSED B ANOTHER FIRM'S PROFESSIONALISM, KNOWLEDGE, & DEDICATION TO QUALITY! A+

140292

HAND STAMP ONLY

Kevin Williams CRSS, Houston, Texas

It's great to be able to attach a name and a place to abstract feedback. I think that these messages really are evidence of people free to do their best— and doing it.

The breadth and depth of your ongoing research efforts reminded us more of an entrepeneurial start-up company than the established industry leader that is Herman Miller.

Lee Rambo Bagley Barnette Bagley Architects, Lexington, Kentucky

**ABB**

April 2, 1993

Mr. Kevin O'Connor
Herman Miller Inc.
Sears Crescent Building
City Hall Plaza
Boston, MA. 02108

Dear Kevin:

. . .

As you are fully aware, in today's times, all companies are very price conscious and ABB PPC is no exception. The competition on this project was intense and to complicate the situation, Herman Miller was at a disadvantage since it had not yet been able to penetrate the ABB Windsor market. I believe that PPC was fair in evaluating the bids and ensuring that we were evaluating each proposal fairly. In the end, with the prices being reasonably close, the final decision came down to Quality of Product, perceived future Service Support, and most importantly Trust, which as you know must be earned. I sincerely believe, in this situation, that PPC has made the right decision.

ABB PPC ended up purchasing around forty of your Series 2 work stations and I believe we were the first sale of your new product line of stand alone furniture, the Geneva Series. I'm sure that there were many of your people involved in this PPC project but there are several people within the Herman Miller organization that I personally interfaced with that deserve significant credit, for without their commitment, perseverance, dedication and trust, the sale would never have taken place.

The first and most significant contributor was your local Account Development Manager, Christine Multari. I must tell you that I have never met anyone with such drive and concern for the client's satisfaction and well being. The first purchasing phase was associated with the modular work stations, which was basically a features, pricing and delivery issue. Chris did an excellent job in helping to identify and explain the differences between the Herman Miller products and the competition. In all honesty, the original Herman Miller/OFI quote was significantly higher than the competition and did not address PPC's needs in a cost effective manner. Chris quickly picked up on this issue and took control of the situation, closely listened to what the client was saying, and resubmitted a proposal that met the clients needs and was price competitive. While this proposal was definitely not the cheapest, Chris's commitment and concern for the client helped to establish a level of trust which was very instrumental in the final PPC decision making process.

The second purchasing phase was associated with standalone office furniture. Herman Miller proposed its yet-to-be launched new line of furniture, the Geneva series, to meet our needs. In this situation, the original

ABB Power Plant Controls

Combustion Engineering, Inc.   2 Waterside Crossing   Telephone (203) 683-8781
                               Windsor, CT 06095        Fax (203) 285-6899

---

Design by Herman Miller in-house design team
Art Director: Stephen Frykholm
Designers: Stephen Frykholm, Yang Kim, Sara Giovanitti
Copywriter: Clark Malcolm
Production: Marlene Capotosto

NEW YORK
Little Italy, 1988
Photo by © Geneviève HAFNER

**Thank you, Herman Miller**
1993 Annual Report   Herman Miller, Inc., and Subsidiaries

CONCRETE JUNGLE IMAGES, Inc
254 E 3rd street - #18 - NYC, NY 10009 - Tel (212) 979-0557

John—
I am very impressed with the World of Herman Miller. Thank you for the valuable insight and gracious hospitality. All of you at HMI continue to open many doors (and windows :-).

VTY—
Nancy Carroll La Jetey, Cook / Jepson Architects
(post of Mary Reiser, C. Multari) Hartford, CT)

---

An annual report for Herman Miller takes a sharp departure from a print category that typically features glossy product shots and vanity photos of CEOs. This effort instead emphasizes Herman Miller's personal, quality service by reproducing correspondence to the company exactly as it was received, and then binding it into a spiral folder. This intentionally unslick approach aims to dazzle with honesty and integrity, instead of beautiful imagery.

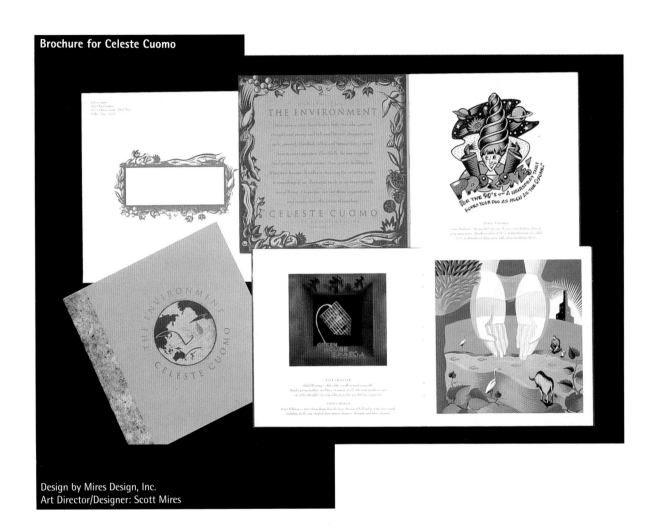

**Brochure for Celeste Cuomo**

Design by Mires Design, Inc.
Art Director/Designer: Scott Mires

A gentle message about protecting the environment was woven into this direct-mail campaign promoting a group of illustrators represented by Celeste Cuomo. The mailer's cover establishes the mood with woodcut images printed on olive paper; subsequent layouts feature illustrations relating to the environment with copy emphasizing their statements on contemporary problems such as global warming and water pollution.

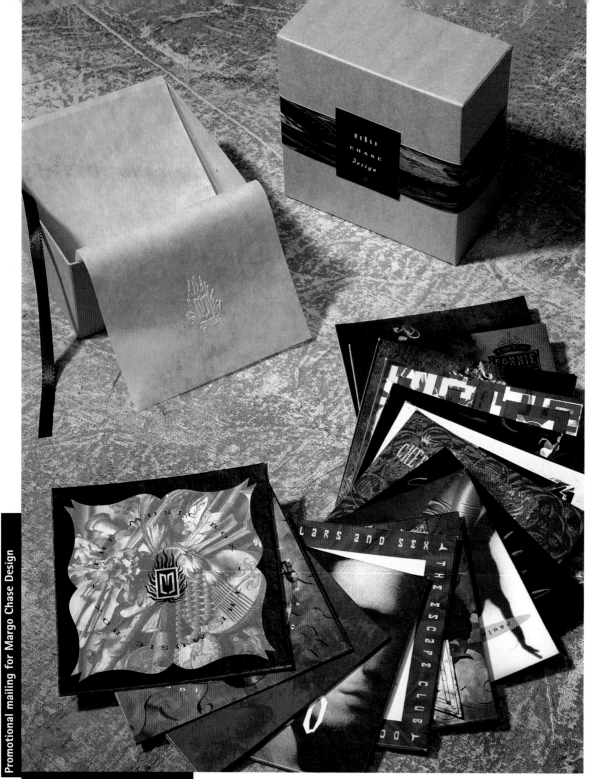

Design by Margo Chase Design
Art Director/Designer: Margo Chase
Photographer: Nels Israelson

A music box containing overprints of CD package designs provides an effective promotion for Margo Chase, who has created contemporary baroque identities for artists such as Prince and Madonna.

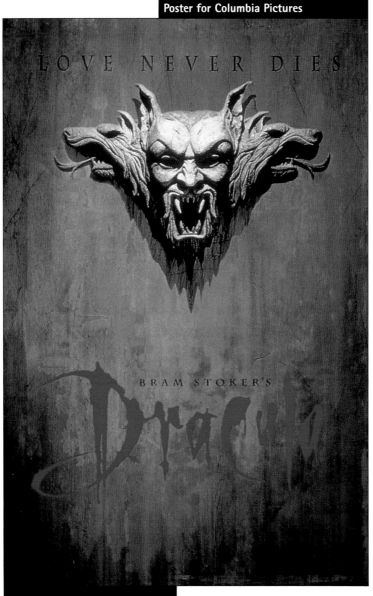

Design by Margo Chase Design
Creative Director: John Kehe
Art Director: Margo Chase
Lettering Designer: Nancy Ogami
Photographer: Sidney Cooper
Sculptor: Jaqueline Perrault

This image of a triple-headed Gothic gargoyle, paired with Nancy Ogami's hand-rendered, bloody title treatment, creates a chilling mood for the film adaptation of Bram Stoker's *Dracula*, one that could not have been achieved by merely showing photographic head shots of the film's stars.

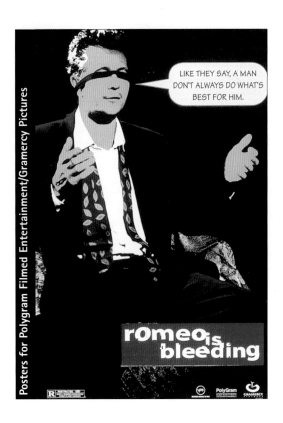

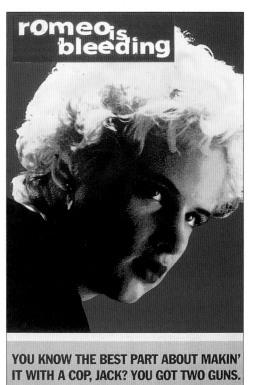

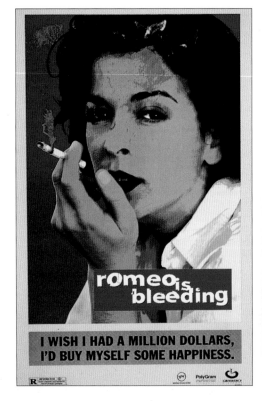

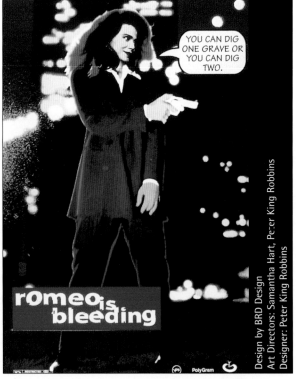

For this film noir production of *Romeo is Bleeding*, a four-poster teaser campaign was used. Each poster promoted one of the four leads in a highly touched-up manner suggestive of 1950s pulp paperback covers. A final poster combined the images with the title and production information.

# romeo is bleeding

The Story Of A Cop
Who Wanted It Bad
And Got It Worse

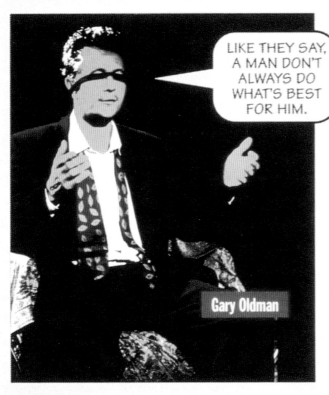

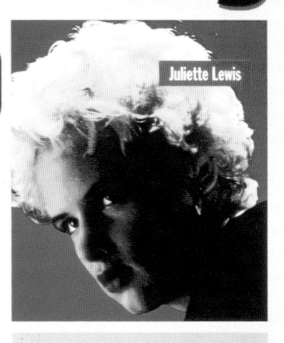

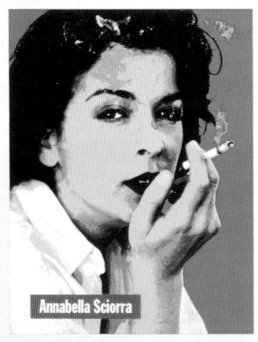

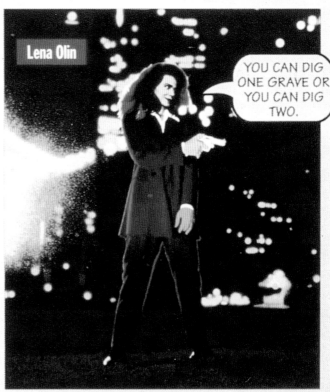

POLYGRAM FILMED ENTERTAINMENT PRESENTS A WORKING TITLE/HILARY HENKIN PRODUCTION
GARY OLDMAN  LENA OLIN  ANNABELLA SCIORRA AND JULIETTE LEWIS A PETER MEDAK FILM "ROMEO IS BLEEDING" AND ROY SCHEIDER
CASTING BY BONNIE TIMMERMAN  MUSIC BY MARK ISHAM  EDITED BY WALTER MURCH  PRODUCTION DESIGNER STUART WURTZEL
DIRECTOR OF PHOTOGRAPHY DARIUSZ WOLSKI  EXECUTIVE PRODUCERS TIM BEVAN AND ERIC FELLNER  WRITTEN BY HILARY HENKIN
PRODUCED BY HILARY HENKIN AND PAUL WEBSTER  DIRECTED BY PETER MEDAK

PolyGram          R RESTRICTED          DOLBY STEREO          GRAMERCY

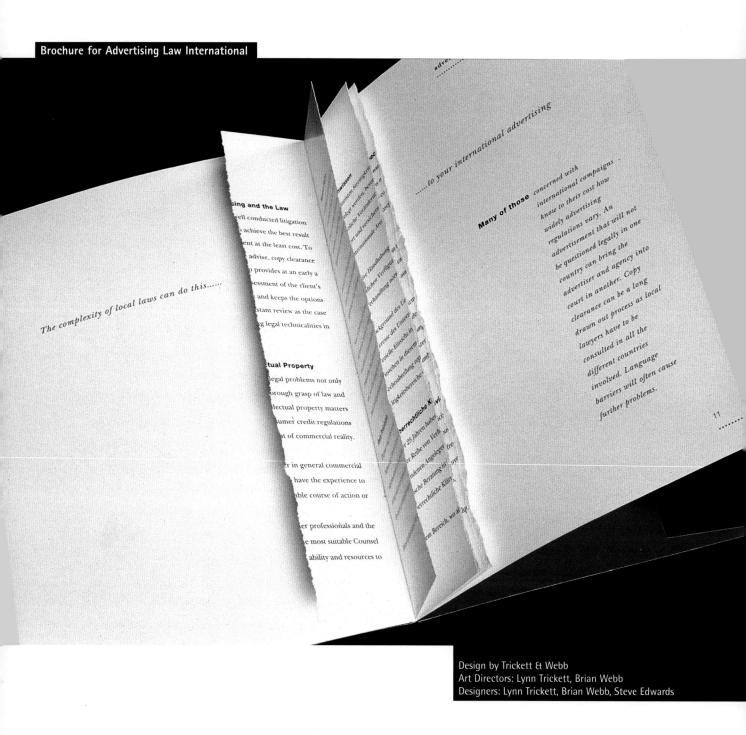

*The complexity of local laws can do this......*

...to your international advertising

**Many of those** concerned with international campaigns know to their cost how widely advertising regulations vary. An advertisement that will not be questioned legally in one country can bring the advertiser and agency into court in another. Copy clearance can be a long drawn out process as local lawyers have to be consulted in all the different countries involved. Language barriers will often cause further problems.

Design by Trickett & Webb
Art Directors: Lynn Trickett, Brian Webb
Designers: Lynn Trickett, Brian Webb, Steve Edwards

Emphasizing the potential legal quagmire faced by advertising agencies marketing overseas, this brochure promoting the services of a group of international lawyers literally demonstrates how the complexity of local laws abroad can rip an advertiser's work to shreds.

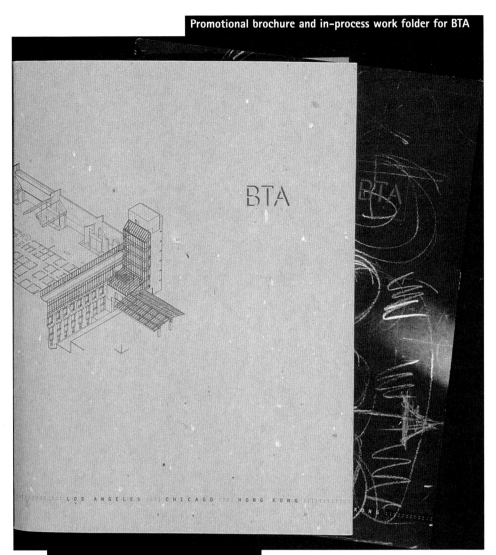

Design by COY
Art Director: John Coy
Designers: John Coy, Albert Choi, Rokha Srey
Production: Rokha Srey

The conservative cover of this brochure for
architectural firm BTA belies the explosion of
energy found within the folder in the form of
idea sketches in chalk. Together with other
elements, including reprints from the
magazine *Architectural Record*, the book
forms a complete picture of the firm,
emphasizing the creative process and the
employees' perspectives.

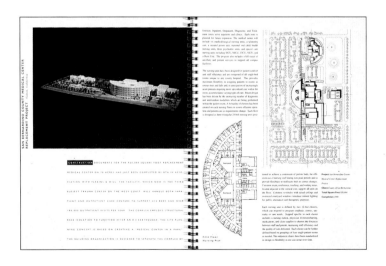

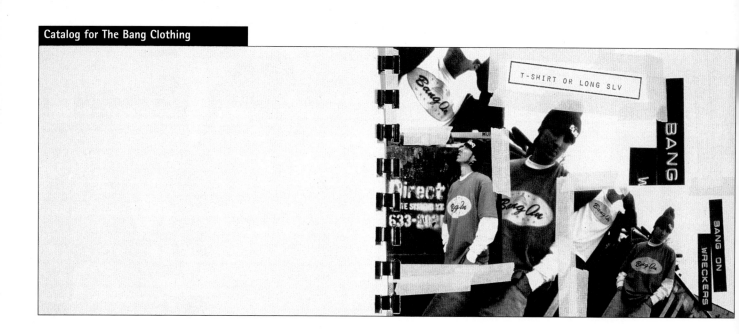

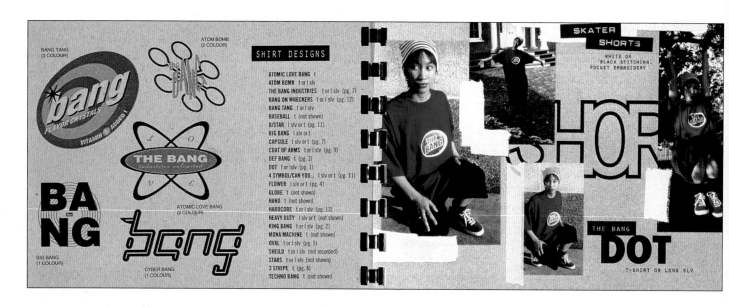

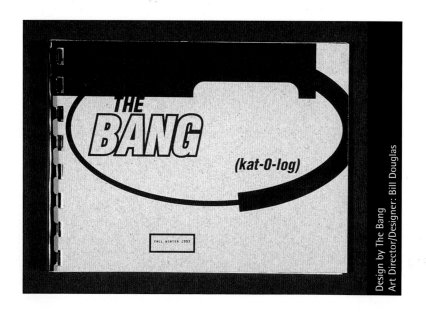

Design by The Bang
Art Director/Designer: Bill Douglas

Designer Bill Douglas' clothing catalog for The Bang maintains street appeal by taking a determinedly unslick approach. Layouts were designed in a scrapbook fashion with photos "taped" down, and some headlines made on a label maker. The piece used low-grade paper stock printed on a color copier.

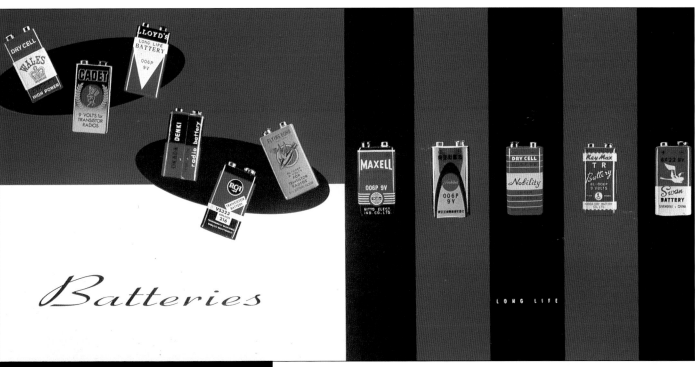

Design by Maureen Erbe Design
Art Director: Maureen Erbe
Designers: Maureen Erbe, Rita A. Sowins
Photographer: Henry Blackham
Copywriter: Aileen Antonier

Layout designs for a book about collectible transistor radios from the 1950s and 1960s use a whimsical format that employs bold use of color, ample white space, and headline type that evokes advertising styles from that era. Type set in a circular shape echoes the shape of a transistor radio speaker.

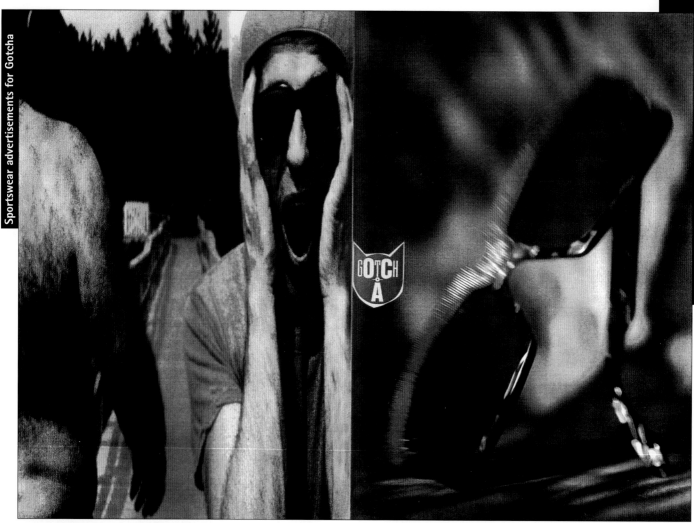

Design by Mike Salisbury Communications
Art Director/Designer: Mike Salisbury

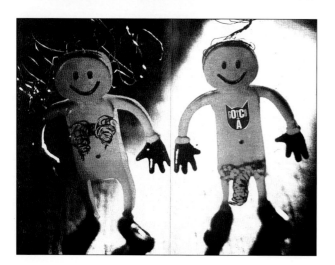

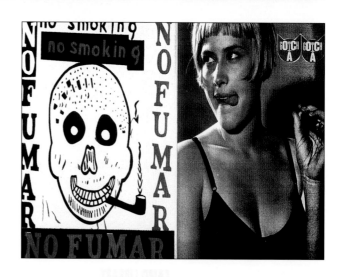

You have to have attitude to appeal to Gen X-ers: One surfwear ad for Gotcha uses edgy photography to spoof an Edvard Munch classic painting; while others rely on vernacular signage and anatomically correct figures that spring to life.

**Direct-mail piece for Hoffman & Angelic Design**

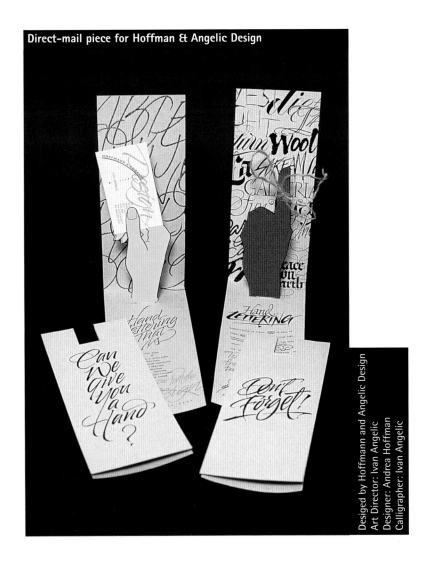

Desiged by Hoffmann and Angelic Design
Art Director: Ivan Angelic
Designer: Andrea Hoffman
Calligrapher: Ivan Angelic

Pop-up hands were used in this direct-mail campaign to promote a design studio's hand-lettering services, while the message and background letterforms reveal the variety of lettering styles.

**Brochure for Food Services of America**

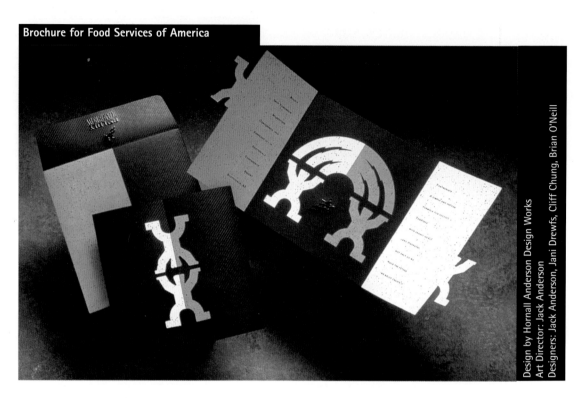

Design by Hornall Anderson Design Works
Art Director: Jack Anderson
Designers: Jack Anderson, Jani Drewfs, Cliff Chung, Brian O'Neill

This brochure for an annual partnership-building conference combines striking color contrast and a bold, almost primitive icon to emphasize the strength and balance in joining forces.

Design by Stewart Monderer Design, Inc.
Art Director: Steward Monderer
Designers: Robert Davison, Jane Winsor
Illustrator: Richard Goldberg

This series of six postcards was conceived to promote a design studio's variety of design approaches, from purely typographic to entirely photographic.

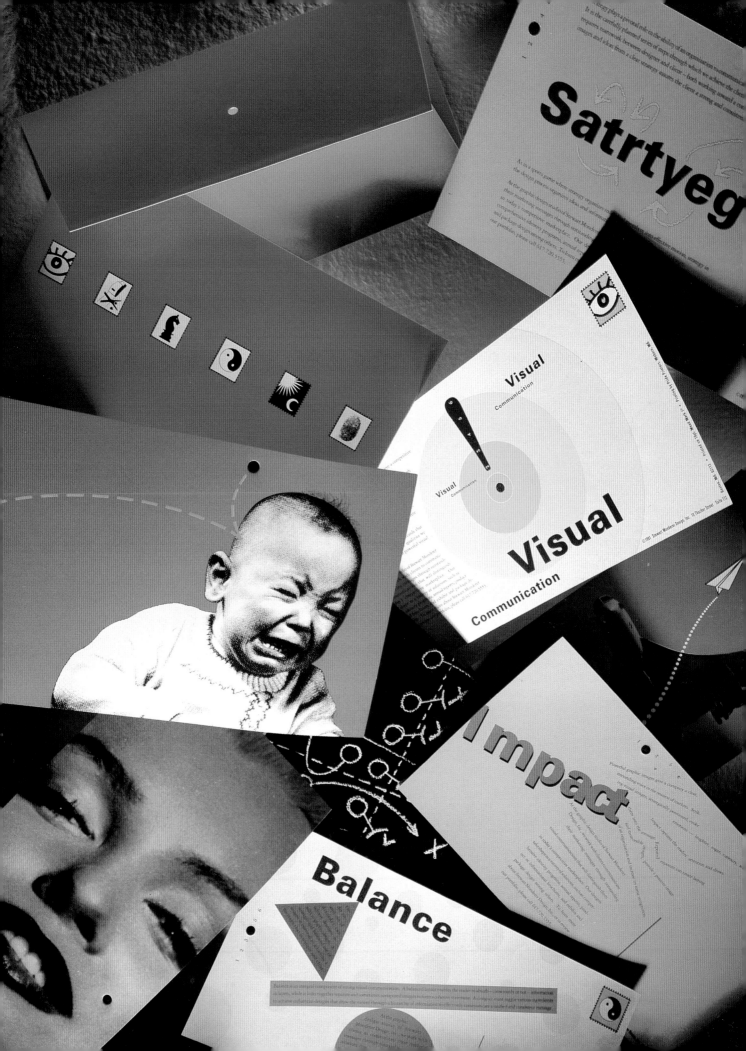

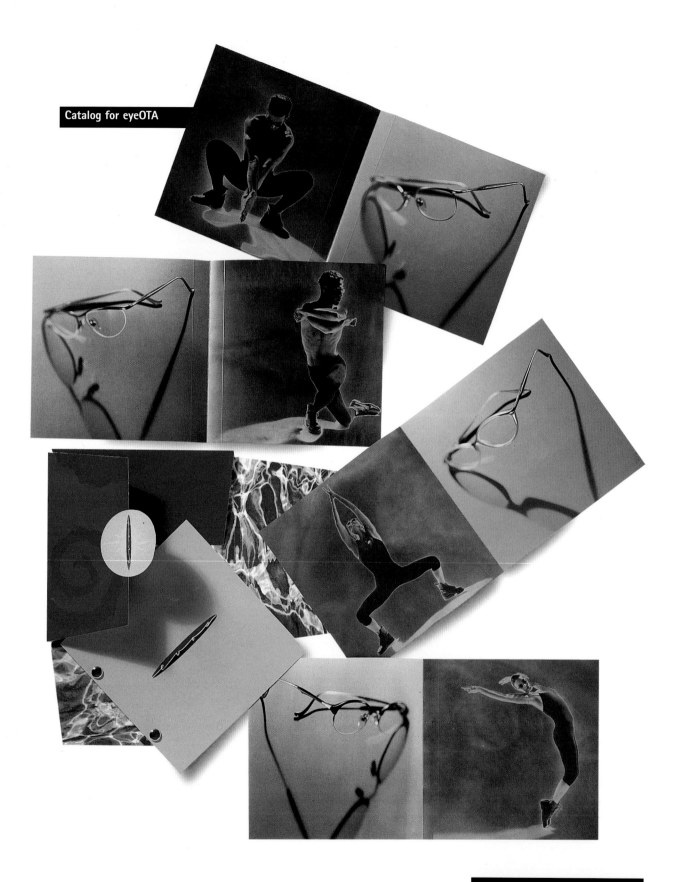

**Catalog for eyeOTA**

In a catalog for eyeOTA, the products' grace, beauty, and elegant lines were emphasized in layouts featuring dramatically lit photographs of eyeglasses paired with shots of professional dancers.

Design by eyeOTA in-house studio
Art Director: David Kilvert
Designers: Krista Kilvert, David Kilvert
Photographer: Amedeo

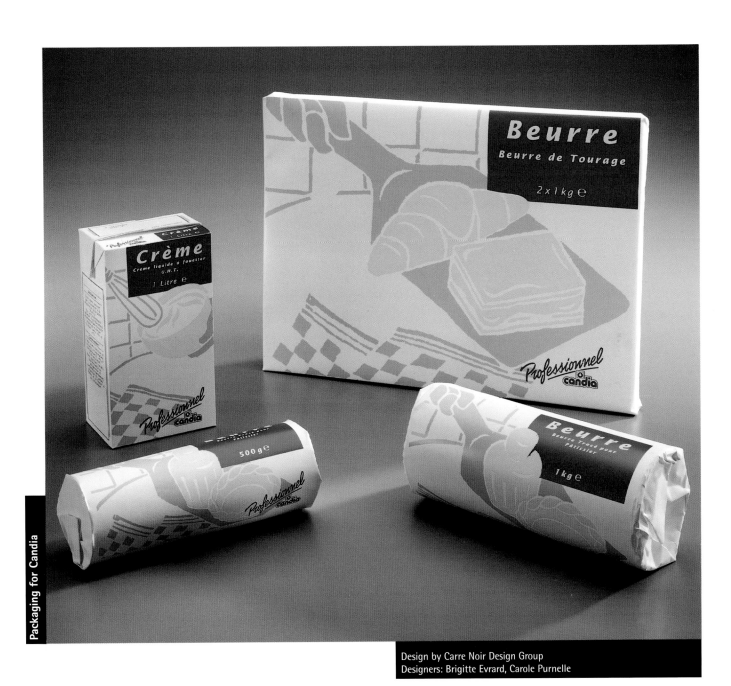

Design by Carre Noir Design Group
Designers: Brigitte Evrard, Carole Purnelle

Packaging for Candia

With an eye-pleasing palette of pastels and silk-
screened imagery reminiscent of 1920s and 1930s,
this package design for a line of French butters
and creams projects an image of quality and purity.

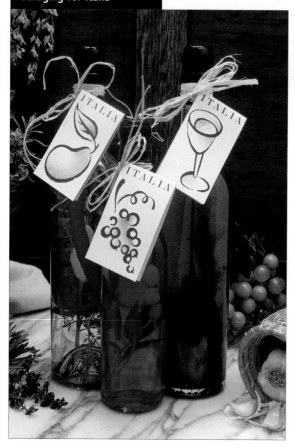

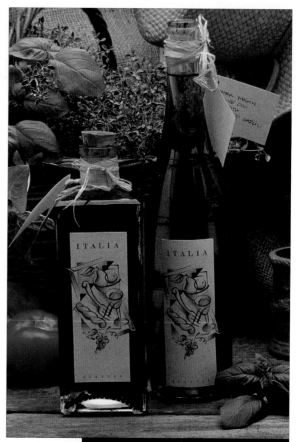

Design by Hornall Anderson Design Works, Inc.
Designers: Jack Anderson, Julia LaPine

Bottles for Italia's line of herbed vinegars and
olive oils exude a casual, yet sophisticated image
through labels and tags with sprightly
illustrations that reveal the source of the essence
and the elements of a fine, simple meal.

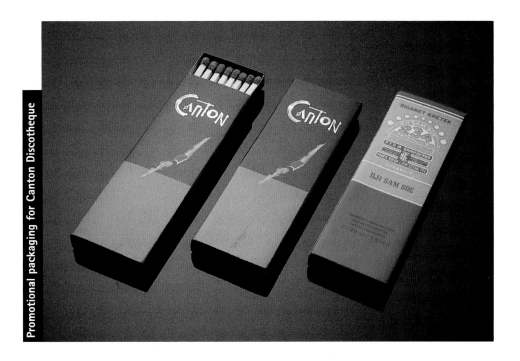

Promotional packaging for Canton Discotheque

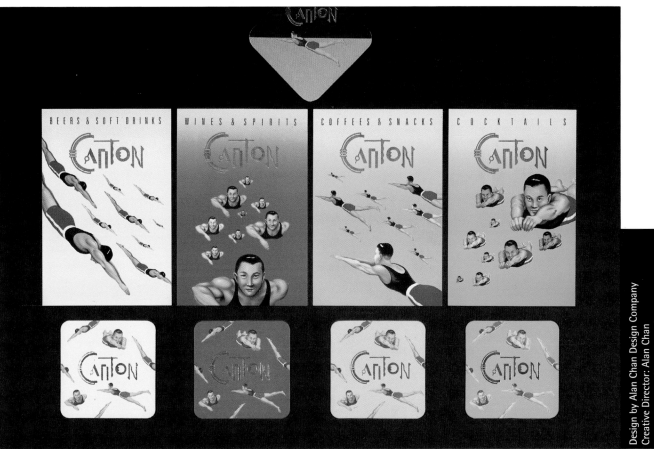

Design by Alan Chan Design Company
Creative Director: Alan Chan
Designers: Alan Chan, Alvin Chan

The packaging for promotional items for the Canton Discotheque projects a hip

sensibility with 1930s-style illustrations on candy-colored backgrounds with a

logo created from a hodgepodge of futuristic letterforms.

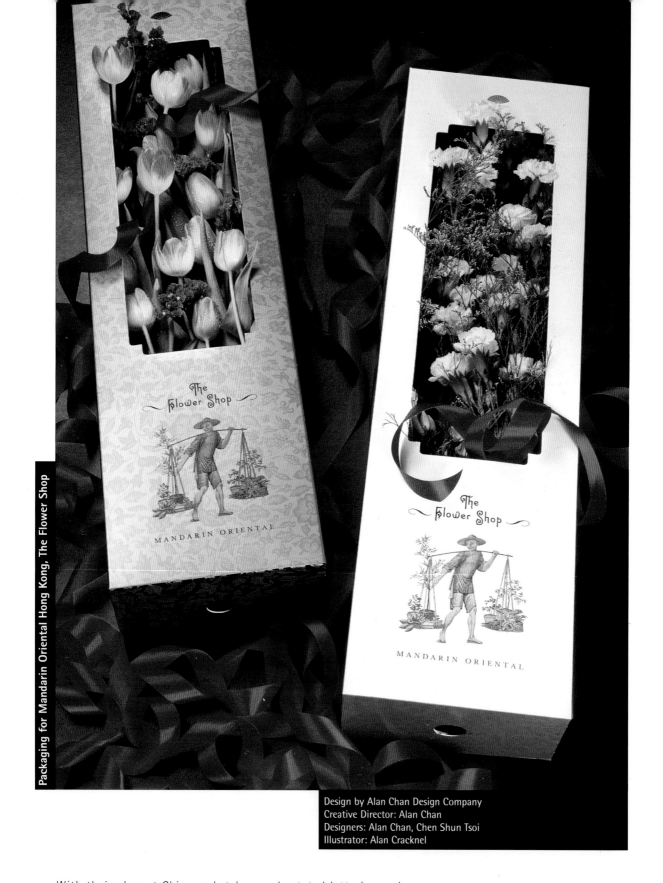

Design by Alan Chan Design Company
Creative Director: Alan Chan
Designers: Alan Chan, Chen Shun Tsoi
Illustrator: Alan Cracknel

With their elegant Chinese sketches, understated lettering and

backgrounds, and an open window for presentation, these floral boxes

employ a beautiful framing device that almost demands that flowers

remain in the package.

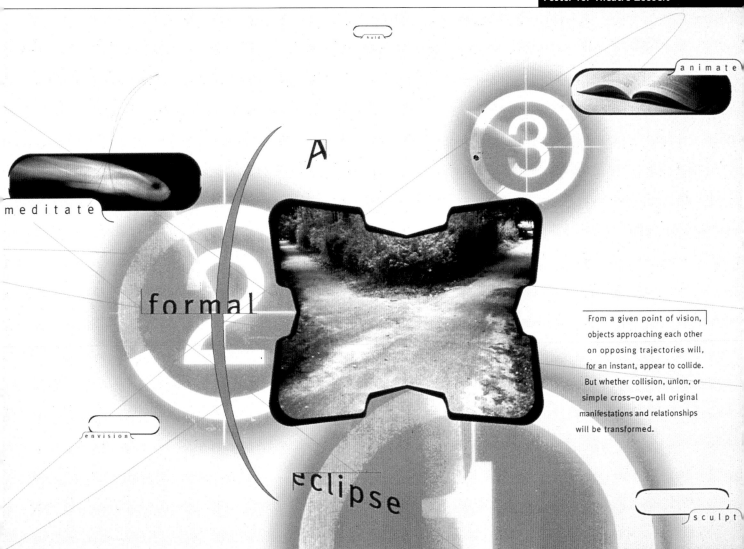

animate

meditate

A

③

formal

From a given point of vision,
objects approaching each other
on opposing trajectories will,
for an instant, appear to collide.
But whether collision, union, or
simple cross-over, all original
manifestations and relationships
will be transformed.

envision

eclipse

sculpt

Design by Studio Dunbar
Art Director: Gert Dunbar
Designer/Photographer: Jeremy F. Mende

things are

*Parity* ®

becoming
more
and
more

the same

For their theater clients in
Holland, Studio Dunbar choose
an elliptical approach in their
poster and brochure designs.
Messages are conveyed
through layouts that
seamlessly weave type, images,
and icons for a textural
approach that speaks to the
subconscious.

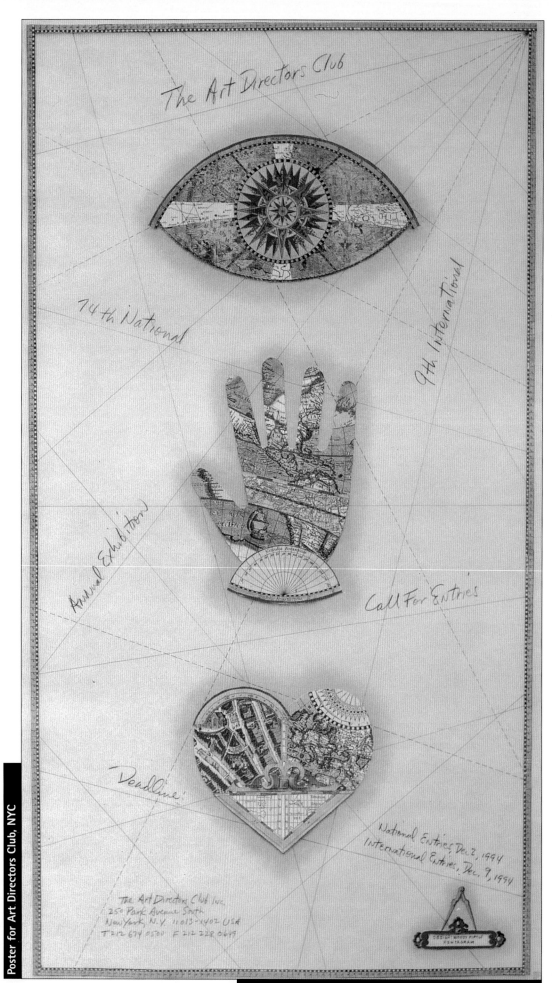

Modern-day hieroglyphics were created to convey three key elements of creativity—the eye, the hand, and the heart—for this call-for-entries poster for the Art Directors Club's annual awards competition.

Design by Pentagram Design
Designer: Woody Pirtle

Poster for Art Directors Club, NYC

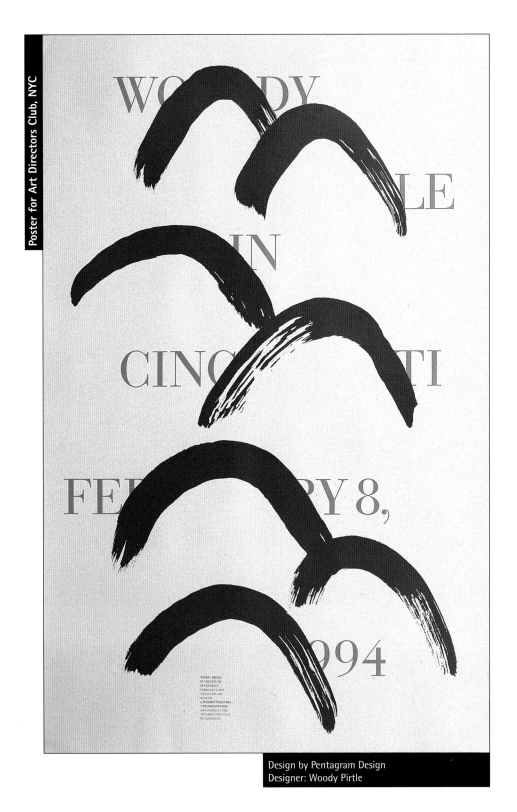

Design by Pentagram Design
Designer: Woody Pirtle

Woody Pirtle used a visual pun on a poster to announce his speaking engagement at the Art Directors Club of Cincinnati. Portions of headline letterforms were replaced with arched brushstrokes representing the City of Seven Hills.

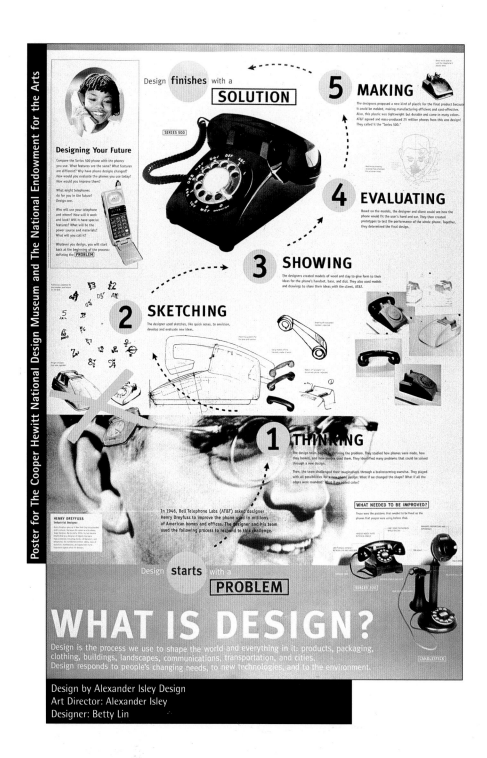

Using his characteristic wit and penchant for iconographic Americana, Alex Isley created a poster that explains the design profession to children in a step-by-step format reminiscent of layouts from vintage issues of *Popular Mechanics*.

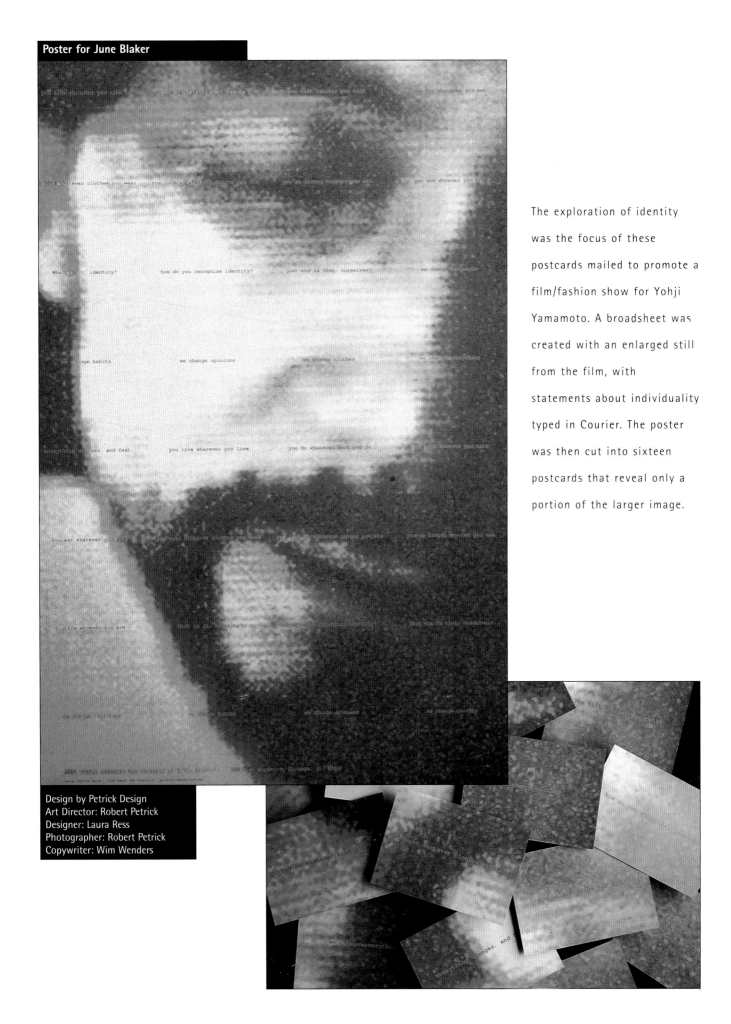

**Poster for June Blaker**

The exploration of identity was the focus of these postcards mailed to promote a film/fashion show for Yohji Yamamoto. A broadsheet was created with an enlarged still from the film, with statements about individuality typed in Courier. The poster was then cut into sixteen postcards that reveal only a portion of the larger image.

Design by Petrick Design
Art Director: Robert Petrick
Designer: Laura Ress
Photographer: Robert Petrick
Copywriter: Wim Wenders

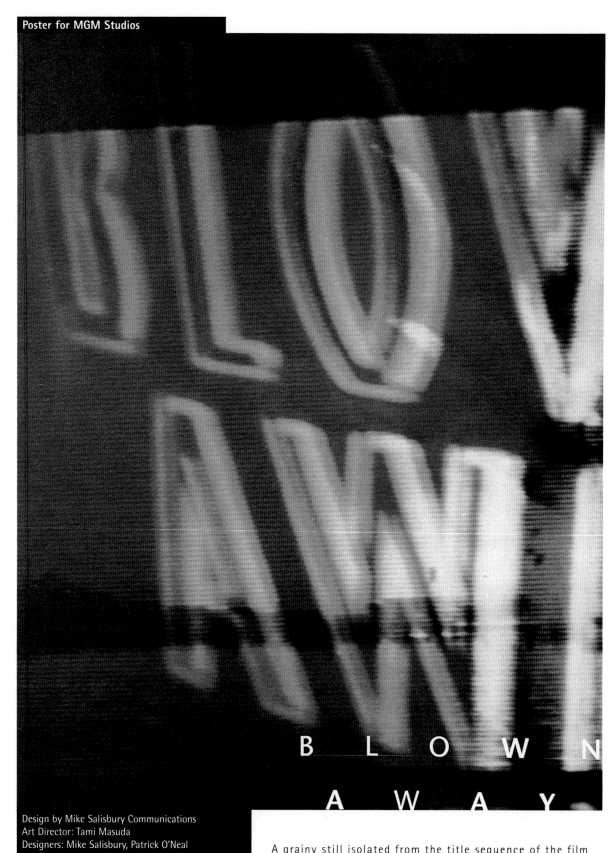

BLOWN
AWAY

Design by Mike Salisbury Communications
Art Director: Tami Masuda
Designers: Mike Salisbury, Patrick O'Neal

A grainy still isolated from the title sequence of the film
*Blown Away* provides impact and hints at the release's gritty
action in this promotional book by Mike Salisbury
Communications.

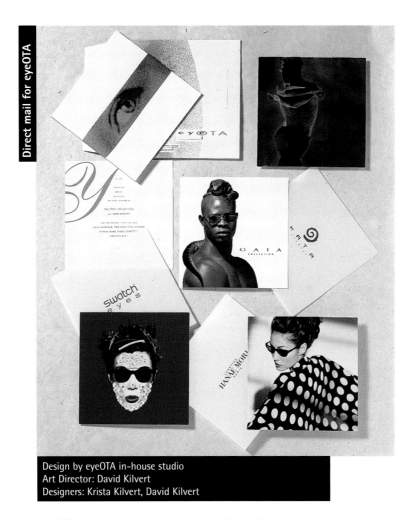

Direct mail for eyeOTA

Design by eyeOTA in-house studio
Art Director: David Kilvert
Designers: Krista Kilvert, David Kilvert

To differentiate between product lines for
eyeOTA, a mailer includes cards promoting
each line with distinctive fashion photography
ranging from the fanciful to the dramatic.
Translucent vellum sheets with the product
logo separate the cards.

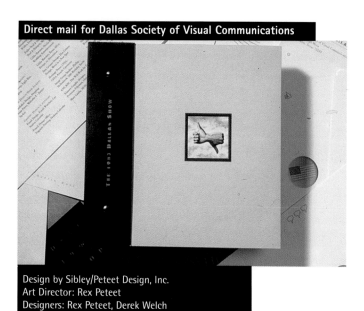

**Direct mail for Dallas Society of Visual Communications**

Design by Sibley/Peteet Design, Inc.
Art Director: Rex Peteet
Designers: Rex Peteet, Derek Welch
Illustrators: Rex Peteet, Derek Welch, Mike Schroeder
Photographer: Phil Hollenbeck

The thumbs-up thumbs-down icon placed at the center of the cover for this call for entries to the Dallas Society of Visual Communicators instantly conveys the essence of competition. The icon is repeated as a motif throughout the booklet.

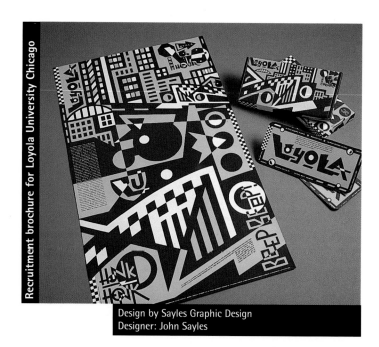

**Recruitment brochure for Loyola University Chicago**

Design by Sayles Graphic Design
Designer: John Sayles

Graphics reflecting a traffic theme are crammed on a page in this booklet promoting the frenetic fun of Loyola University's fraternity and sorority rush.

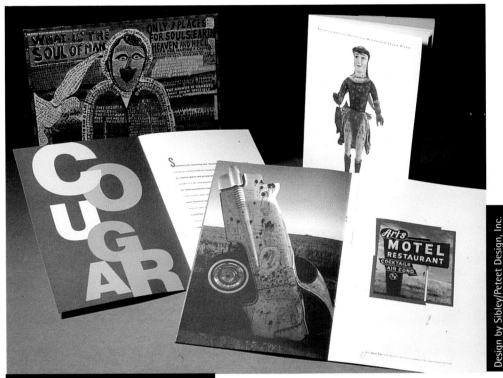

Icons of Americana, from roadside signs to folk art, grace the cleanly designed and clutter-free pages of a promotion for Weyerhaeuser paper.

Design by Sibley/Peteet Design, Inc.
Designer: Don Sibley

**Direct mail for Weyerhaeuser**

The mode of shelter used by so many homeless people—a cardboard carton—is the key image in this mailer for a nonprofit organization. The image of a crouching homeless man is literally boxed in by corrugated markings.

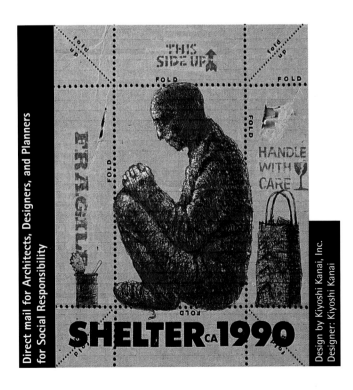

Direct mail for Architects, Designers, and Planners for Social Responsibility

Design by Kiyoshi Kanai, Inc.
Designer: Kiyoshi Kanai

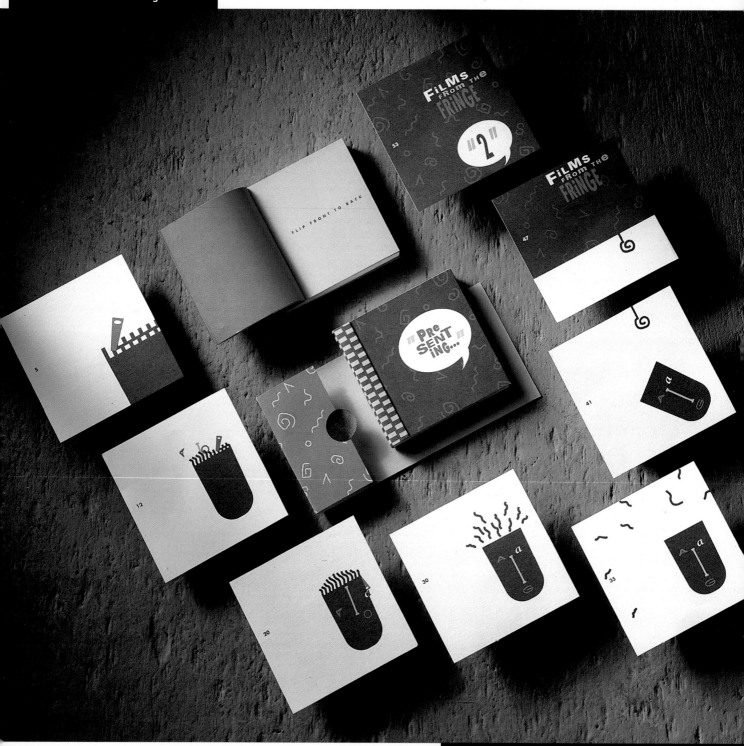

Designers: Melanie Bass, Julie Sebastianelli, Richard Hamilton, Jim Jackson, Jake Pollard, Andres Tremois, Pam Johnson

A flip book was created to promote an animated film festival for the AIGA Washington: Opening pages create a kind of title sequence with type, while the remaining pages establish a whimsical mood with type and squiggly hair that dances off the page.

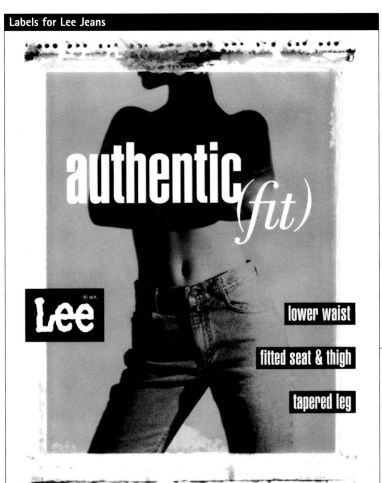

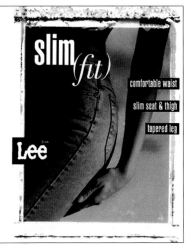

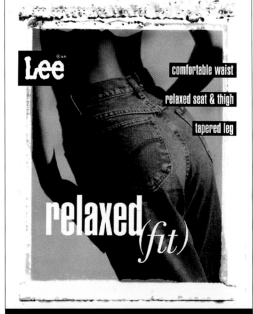

Design by Muller + Company
Designer: David Schultz
Art Director: John Muller
Photographer: Mike Regnier

These labels for Lee Jeans present the differences in styles with parentheses around the word "fit" for added emphasis. The use of shadowy, uncropped photography adds a certain edge.

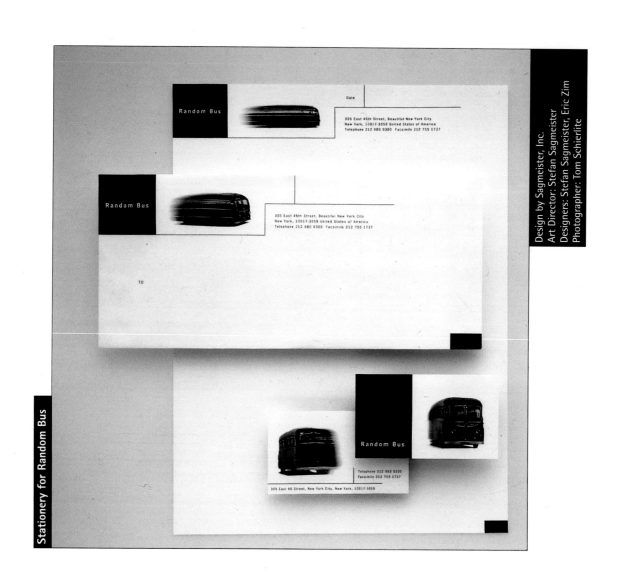

Design by Sagmeister, Inc.
Art Director: Stefan Sagmeister
Designers: Stefan Sagmeister, Eric Zim
Photographer: Tom Schierlitz

**Stationery for Random Bus**

Whimsy and fun zoom across letterhead for Random Bus, with an image of a toy bus doctored up in Photoshop. The sense of movement continues with rules and type that fall horizontally across the page.

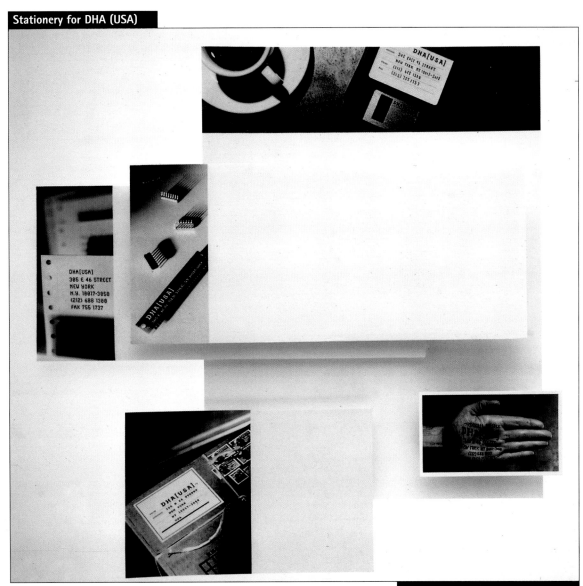

Design by Sagmeister, Inc.
Art Director/Designer: Stefan Sagmeister
Photographer: Tom Schierlite

An unusual photographic approach was taken for the letterhead design for DHA (USA). Elements in the photographs instantly communicate the high-tech business's focus with shots of computer-related tools of the trade. Necessary copy is cleverly incorporated into the images themselves.

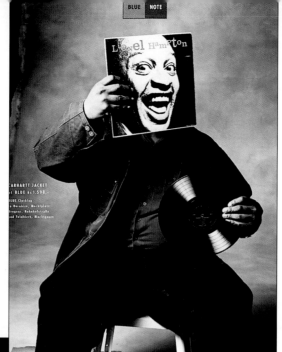

## Blue Posters

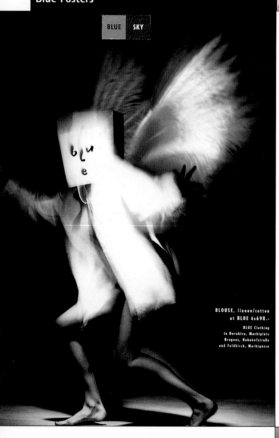

The solution was in the bag for clothing retailer Blue: It allowed the designers to use friends to model the clothing on a limited budget, as well as promoting the line as being fun to wear.

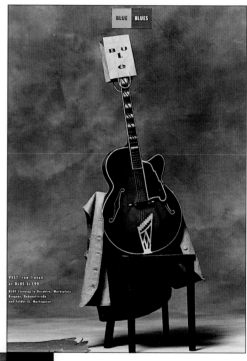

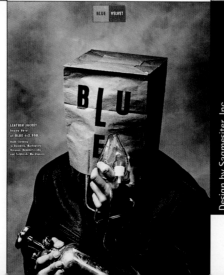

Design by Sagmesiter, Inc.
Art Director/Designer: Stefan Sagmeister
Photographer: Tom Schierlite

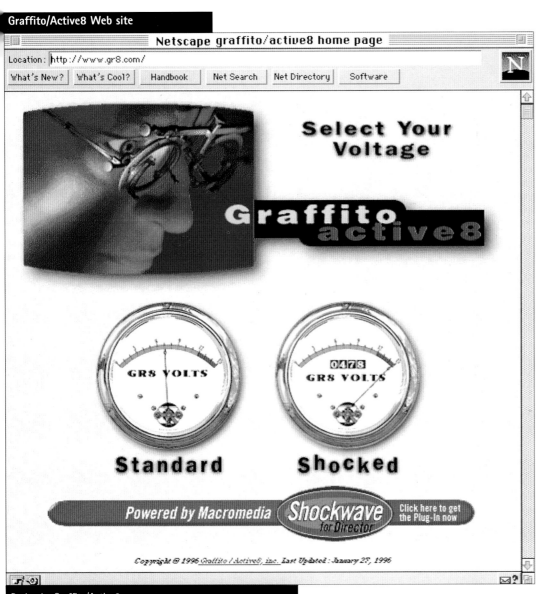

Design by Graffito/Active8
Designers: Tim Thompson, Jon Majerik
Illustrator: Josh Field
Programmer: Jon Majerik
Photographers: Ed Whitman, Taran Z., Michael Northrup

This Web site for Graffito/Active8 eschews the typical visual clutter so often found on the Internet for a clean, easy-to-navigate format that is highly graphical. Type is kept at a minimum to allow the design studio's work to speak for itself.

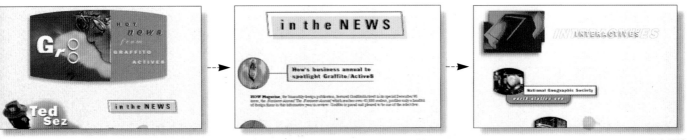

# DEAR SANDY

### Dear Food Lovers,

Chinese New Year is coming up soon. Why not make a special New Year's Feast? We provide two recipes in the Quick Cook section of What's Cooking.

Our Valentine's Day feature in the Market Basket section of Fresh this Week offers heart-healthy tips for year-round cooking.

And don't forget to fill out a Feedback form if you haven't yet done so. We value input from you about your cooking habits to guide us in recipe selection for our site. It's especially important to hear from you this week, because next week we'll be changing our questions to focus on bread machines.

If you've sent an e-mail to us and haven't heard back, please be patient, because we are swamped with requests right now, but we do answer every e-mail question Also, please be sure your e-mail address is correct when you send your question. We've had a number of our responses returned because of faulty addresses.

### Happy Chinese New Year!

# WHAT'S COOKING

**What to cook? What to eat? An age-old problem. Check out these solutions.**

 ### Ketchum Cookbook

We're building a cookbook! Here you'll find deliciously easy appetizers; bread machine bread that tastes as good as grandma's; main dishes made in minutes; good things to grill; tantalizing, deceptively lowfat desserts… More tempting recipes will be added continually to this database.

 ### Quick Cook

Fast and good. These recipes help meet the dinnertime crunch. Even if you left work late.

# WHAT'S COOKING

# KETCHUM COOKBOOK

 Here's a library of our favorite recipes. Search by recipe category or by key ingredient. Keep your key ingredient general (to find steak, search beef; to find potatoes, search vegetables). Or browse through the whole collection.

Search by Category.................... | Appetizers / Breads / Cakes / Condiments |

[Find]

What to cook? What to eat? An age-old problem. Check out these solutions.

 Ketchum Cookbook

We're building a cookbook! Here you'll find deliciously easy appetizers; bread machine bread that tastes as good as grandma's; main dishes made in minutes; good things to grill; tantalizing, deceptively lowfat desserts… More tempting recipes will be added continually to this database.

Quick Cook

What's fresh, what's hot, what's happening? Here's the place to find out.

 Celebrity Chef

Who's making food news? Who's influencing what we buy and how we eat? Meet our guest!

 **Market Basket**

# FRESH THIS WEEK

## CELEBRITY CHEF

 Gary Danko started cooking when he was six. And he hasn't stopped since. Today, he is chef of The Dining Room at the elegant Ritz-Carlton, San Francisco, preparing fabulous dishes that have won him many accolades, including the James Beard Best American Chef: California, award last spring. As a child, Gary's first culinary adventures began with Betty Crocker cookbooks. Today, this French-trained chef wins critical acclaim from national wine and food critics. Gary shares a recipe for Grilled Beef with Dried Tomatoes and Artichoke Hearts, which he has adapted for home

Design by Red Dot Interactive
Creative Director: Judith Banning

Ketchum Kitchen's Web site puts a homey face on a division of this large advertising and public-relations firm. The site is a working test kitchen, with recipes and cooking tips. A cozy-kitchen atmosphere is created with casual line drawings of steaming coffee cups and sizzling pans; scrolled and floral backgrounds evoke a kitchen-wallpaper touch.

ECCO Cricket

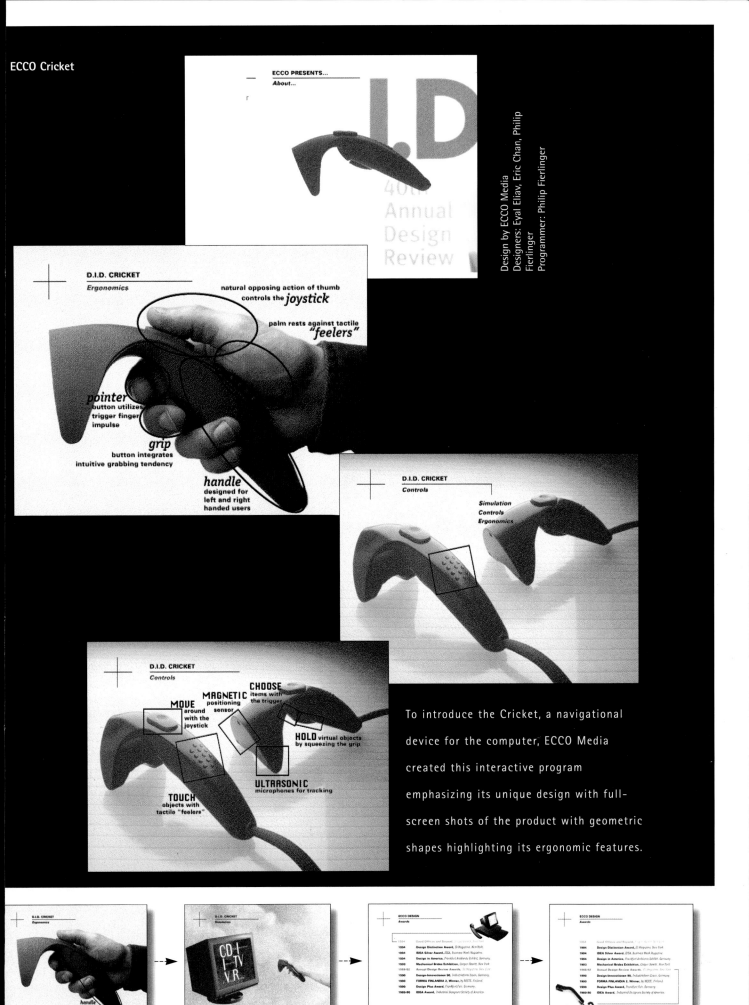

Design by ECCO Media
Designers: Eyal Eliav, Eric Chan, Philip Fierlinger
Programmer: Philip Fierlinger

ECCO PRESENTS...
About...

I.D
40th
Annual
Design
Review

**D.I.D. CRICKET**
*Ergonomics*

natural opposing action of thumb controls the *joystick*

palm rests against tactile *"feelers"*

*pointer*
button utilizes
trigger finger
impulse

*grip*
button integrates
intuitive grabbing tendency

*handle*
designed for
left and right
handed users

**D.I.D. CRICKET**
*Controls*

Simulation
Controls
Ergonomics

**D.I.D. CRICKET**
*Controls*

**CHOOSE** items with the trigger

**MAGNETIC** positioning sensor

**MOVE** around with the joystick

**HOLD** virtual objects by squeezing the grip

**ULTRASONIC** microphones for tracking

**TOUCH** objects with tactile "feelers"

To introduce the Cricket, a navigational device for the computer, ECCO Media created this interactive program emphasizing its unique design with full-screen shots of the product with geometric shapes highlighting its ergonomic features.

The use of subtle graphic wit conveys the design sensibilities of Primo Angeli's design firm on its Web site. The home page is organized with simple graphic icons to steer users to areas of interest. Other pages use a dramatic black-and-white format with logos and borders highlighted in red.

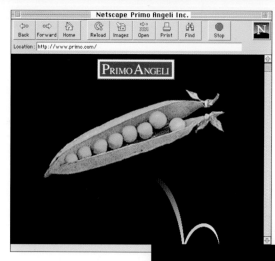

Netscape Primo Angeli Inc.

Location: http://www.primo.com/

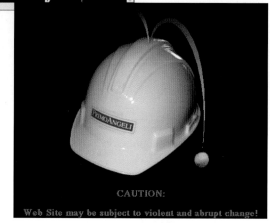

CAUTION:
Web Site may be subject to violent and abrupt change!

**Web site for Primo Angeli Inc.**

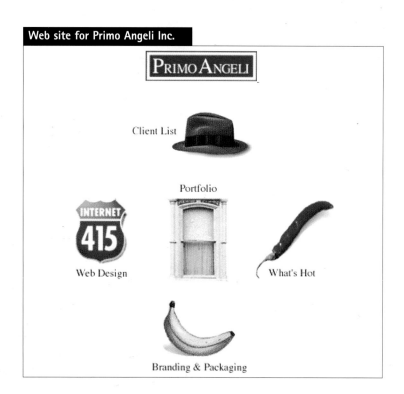

PRIMO ANGELI

Client List

Portfolio

INTERNET 415
Web Design

What's Hot

Branding & Packaging

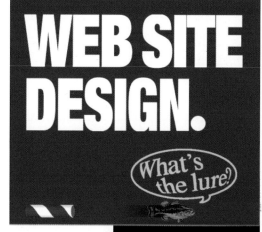

WEB SITE DESIGN.

What's the lure?

Design by Primo Angeli, Inc.
Creative Director: Primo Angeli
Art Directors: Primo Angeli, Brody Hartman
Designers: Philippe Becker, Dom Moreci
Illustrator: Mark Jones
Programmer: Dom Moreci

WEB DESIGN

On the ocean that comprises the Internet, powerful signals and memorable messages are the best lures for fishing.

PRIMO ANGELI

CLIENT LIST:

COCA-COLA USA

ATLANTA

Henry Weinhard's
ROOT BEER

BROWN & HALL

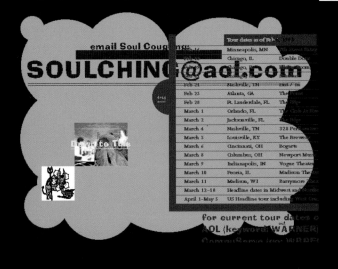

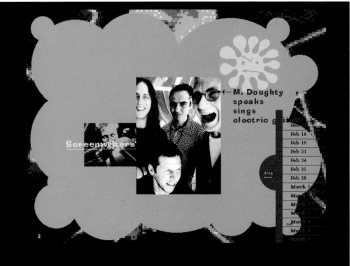

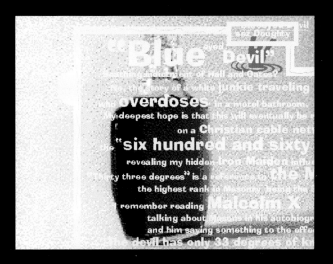

Design by Aufuldish & Warinner
Art Director: Bob Aufuldish; Kim Biggs (Warner Bros. Records)
Creative Director: Jeri Heiden (Warner Bros. Records)
Programmer: Bob Aufuldish

This interactive press kit for the rock band Soul Coughing employs an irreverent, upbeat style created through the use of amorphic background shapes, jarring color combinations, and highly pixellated images.

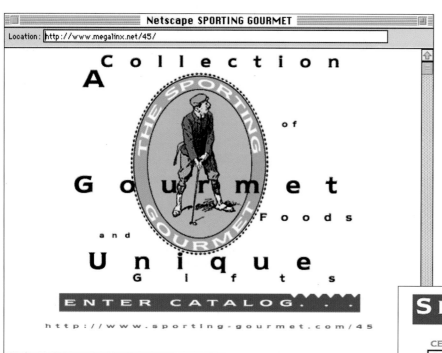

**Catalog for Sporting Gourmet**

An online catalog for the Sporting Gourmet employs an easy to navigate format to direct viewers to a wide range of gift items. The design employs an ample use of white space, with product categories called out in colored type. The long vertical page format reduces the number of necessary links.

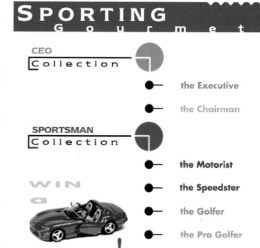

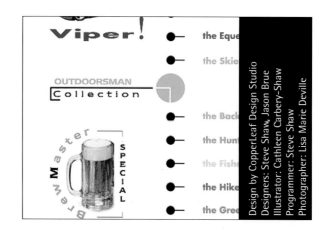

Design by CopperLeaf Design Studio
Designers: Steve Shaw, Jason Brue
Illustrator: Cathleen Carbery-Shaw
Programmer: Steve Shaw
Photographer: Lisa Marie Deville

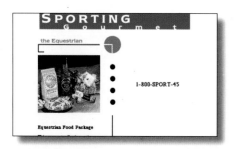

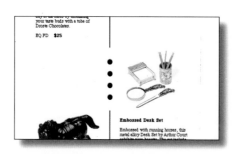

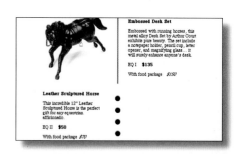

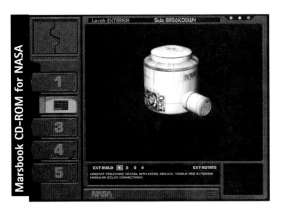

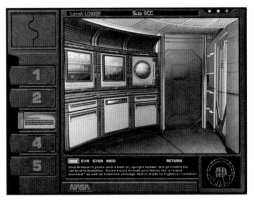

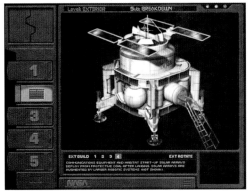

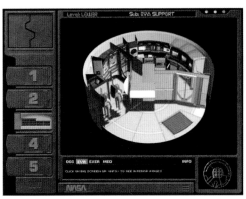

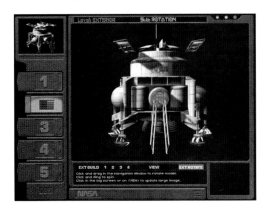

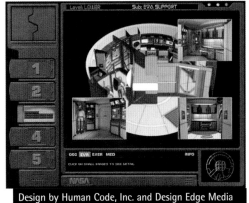

**Design by Human Code, Inc. and Design Edge Media Integration**
**Designers: Chipp Walters, Lindsay Gupton, Reed McCullough, Nathan Moore, David Gutierrez**
**Programmer: Gary Gattis**

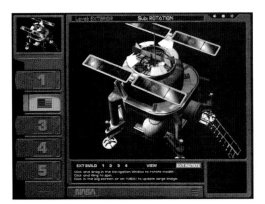

Screens within this complex and highly detailed interface for *Marsbook CD*, produced for NASA as a guide to its Initial Planned Mars Habitat, has the appearance of a futuristic space control panel, with beveled matte-gray control buttons, black background, and illuminated type.

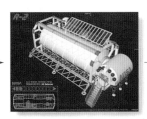

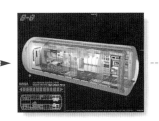

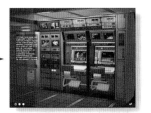

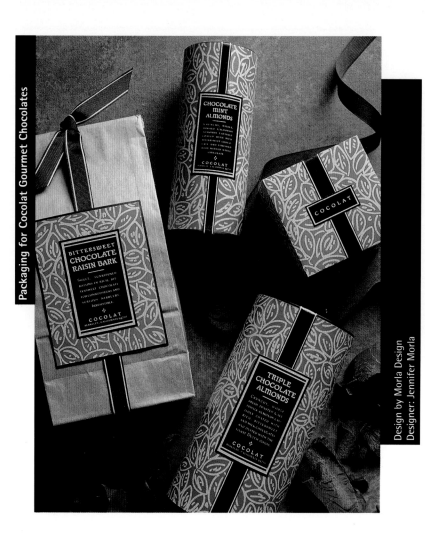

Design by Morla Design
Designer: Jennifer Morla

Labels and tubes illustrated with a abstract leaf pattern, affixed with pastel-toned labels and printed on tactile recycled paper stock give packages for Cocolat chocolates an upmarket yet homey image. A black ribbon adds a sophisticated touch.

Design by Clifford Selbert Design
Art Director: Clifford Selbert
Designers: Melanie Lowe, Linda Kondo

These boxes for Converse sneakers humorously play with perspective: The outside of the boxes hint at their contents by showing the images of the shoes shot from the front, back, top and sides.

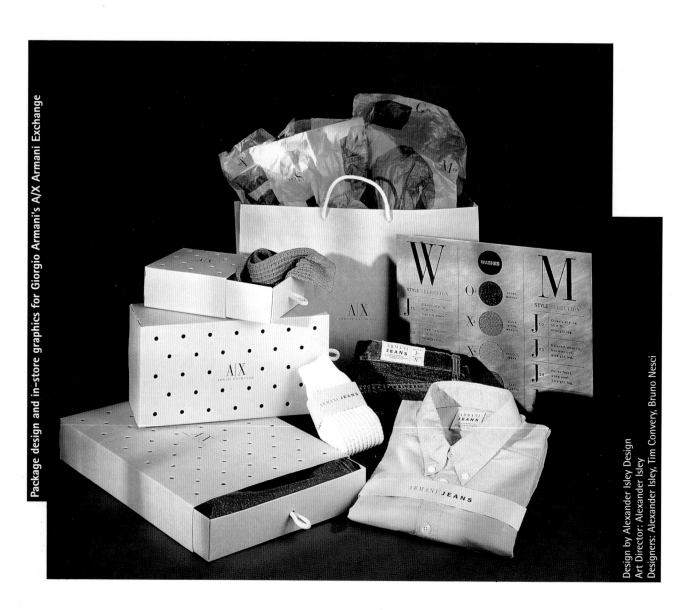

Design by Alexander Isley Design
Art Director: Alexander Isley
Designers: Alexander Isley, Tim Convery, Bruno Nesci

For A/X Armani Exchange, designer Alexander Isley reflects the stores' minimalist interiors with his package designs and in-store graphics that have an industrial edge: Gift boxes have die-cut perforations and shopping bags sport handles made of rope.

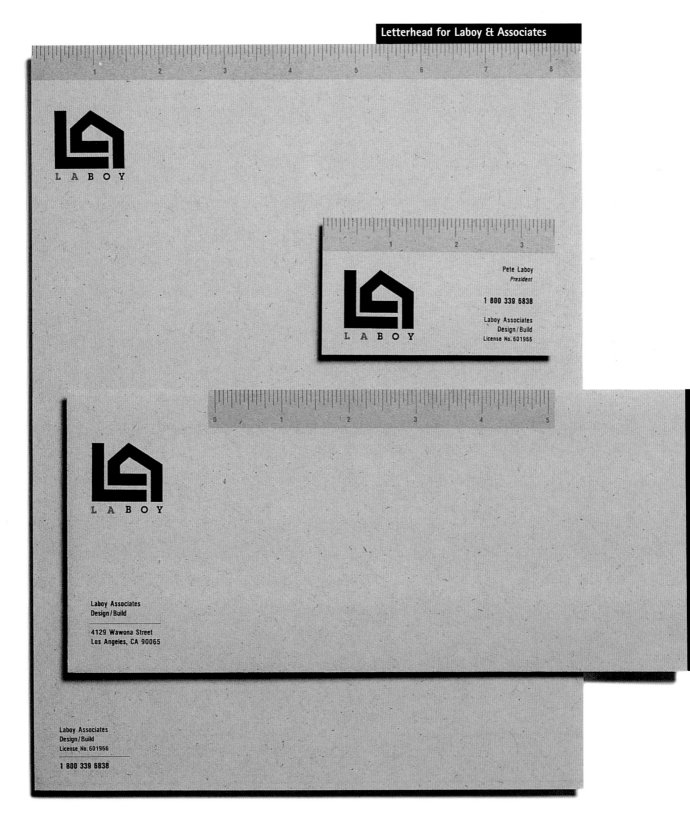

Sometimes simplicity is best: Stationery for Laboy edged in a ruler instantly identifies this company's interests in construction. A logo designed to look like a house cements the image.

Design by Sayles Graphic Design
Designer: John Sayles

John Sayles' kinetic illustration style lends a modern touch to stationery for this bridal and formal-wear shop. The background design of printed pieces is composed of a jumble of nuptial symbols, such as wedding bells, gift boxes, and tiny hearts.

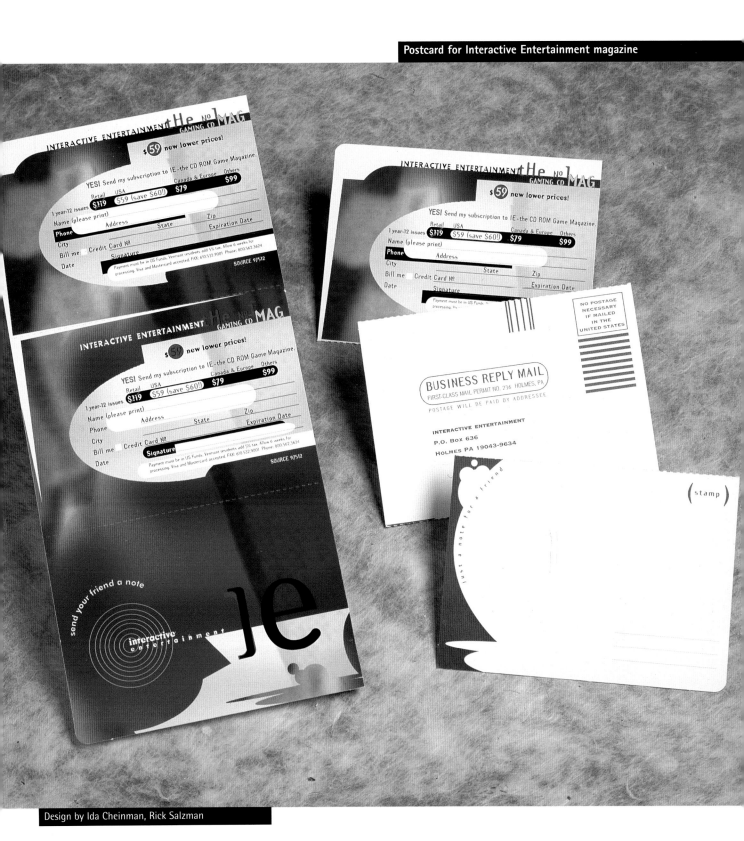

Design by Ida Cheinman, Rick Salzman

Subscription cards for a CD-ROM computer gaming publication emulate the computer-screen environment with a format that feels as though the reader is scrolling through content. The appearance of three-dimensional, floating letterforms and text set in amorphic shapes add to the free-flowing experience.

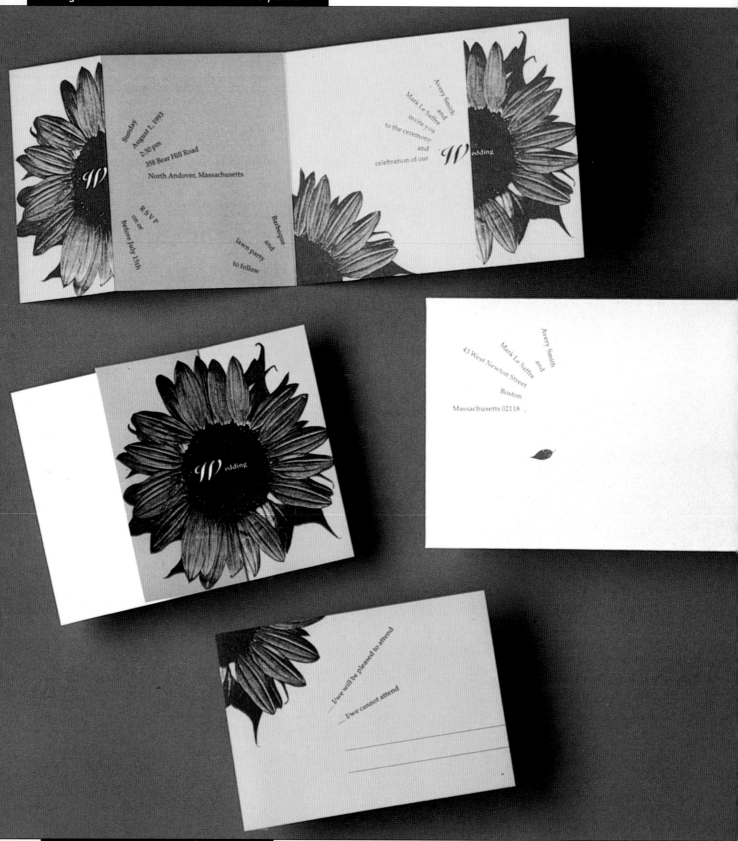

Design by Laughlin/Winkler, Inc.
Art Directors/Designers: Mark Laughlin, Ellen Winkler

This wedding invitation captures both the essence of summer and the casual spirit of the event itself with a sunflower motif with petals replaced by lines of copy. The theme is hinted at on the envelope with splayed type and a single petal.

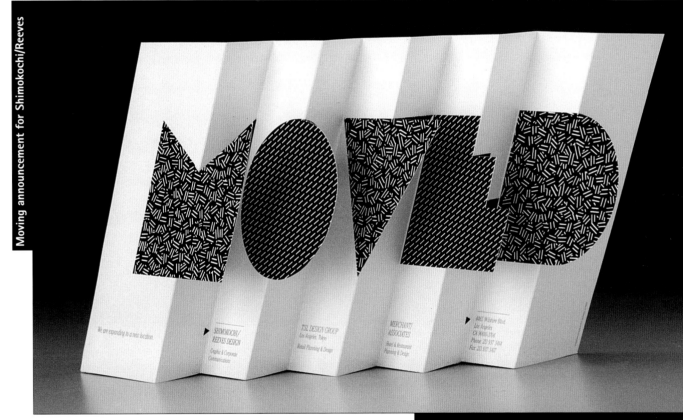

Design by Shimokochi/Reeves
Art Directors/Designers: Mamoru Shimokochi, Anne Reeves

Italic letterforms are often used to convey motion, but in this moving
announcement, the card itself is fashioned to be a tilting parallelogram.
The accordion pleats humorously emphasize the design firm's expansion.

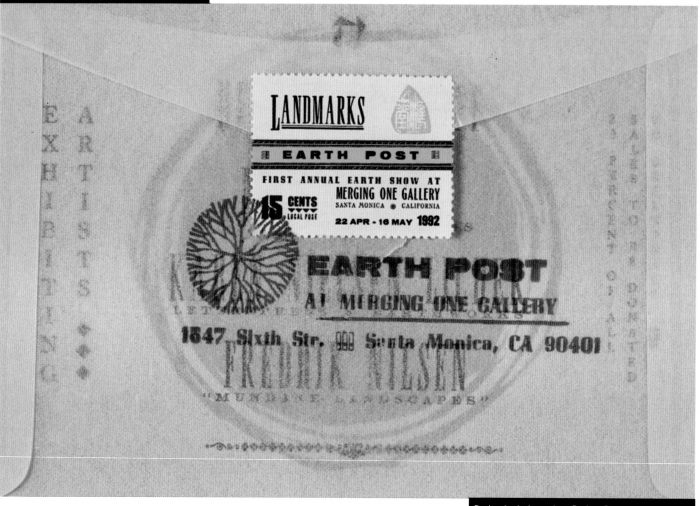

Design by Independent Project Press
Art Directors/Designers: Bruce Licher, Karen Licher
Photographer: Bruce Licher

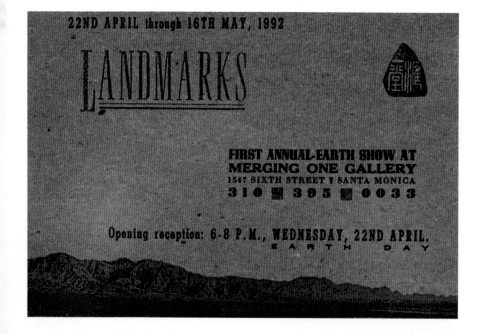

This vellum envelope subtly reveals the invitation that awaits inside to an Earth Day art exhibit. The message of environmental preservation is carried out with earth-toned inks printed on chipboard using a letterpress.

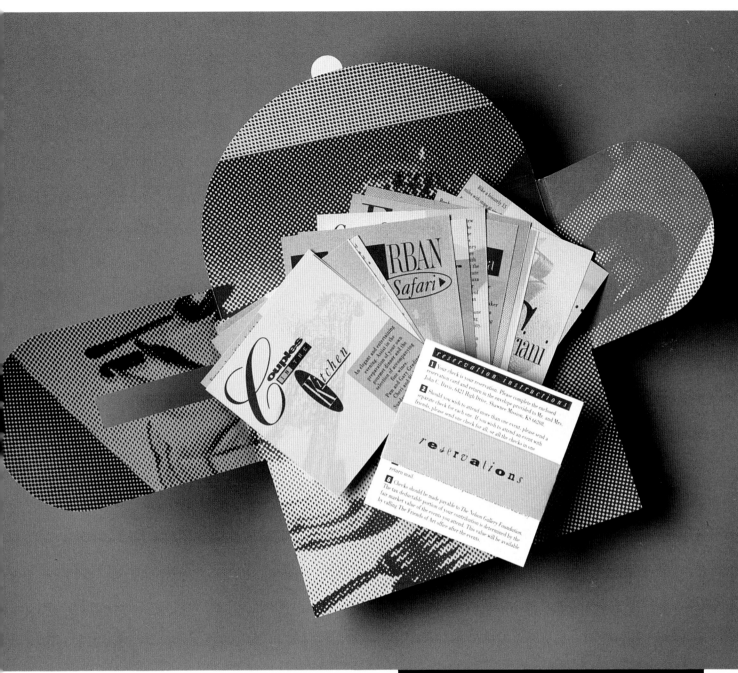

Design by Muller + Company
Art Director: John Muller
Designer/Photographer: Peter Corcoran

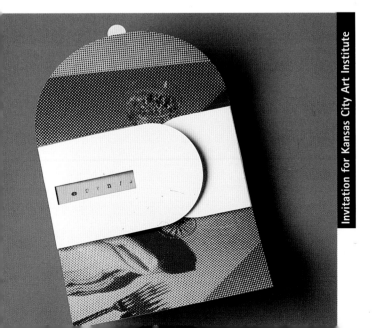

For the Couples in the Kitchen fund-raising dinner series, Muller + Company created an envelope that folded like a cloth napkin, with halftone images of a table setting. Inside, a stack of cards designed with screened images of food and drink describe individual events.

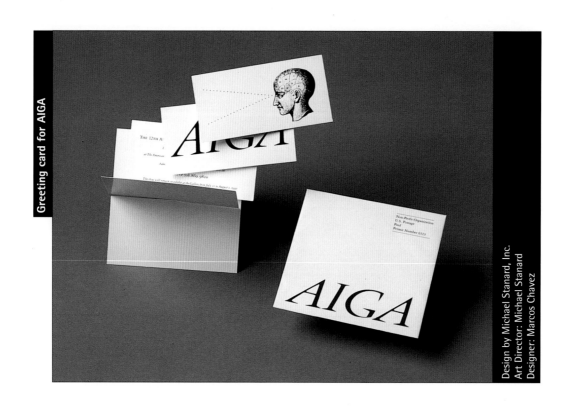

Design by Michael Stanard, Inc.
Art Director: Michael Stanard
Designer: Marcos Chavez

An antique medical drawing illustrating

the portion of the brain controlling

vision is used to announce an exhibit for

the American Institute of Graphic Arts

while maintaining the professional

society's clean, classic identity.

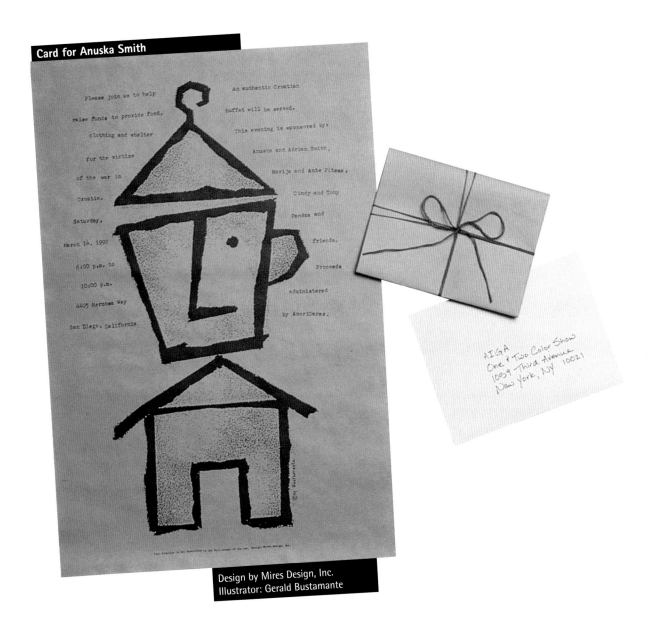

**Design by Mires Design, Inc.**
**Illustrator: Gerald Bustamante**

A fund-raiser for victims of the Croatian war is poignantly announced with an illustration that pulls together the elements of food, clothing, and shelter to create a touching anthropomorphic image. The use of a typewriter font and simple paper stock conveys the charitable spirit.

**Card for Greater Cincinatti Tall Stacks Commission, Inc.**

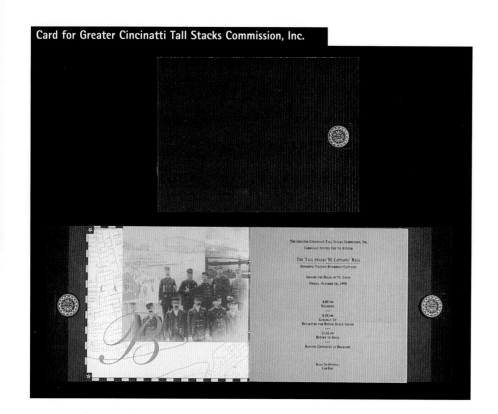

This invitation to the Tall Stacks Captains Ball in Cincinnati pays tribute to nineteenth-century high society with a fold-out sepia-toned format that incorporates alternating vintage images of riverboats and social events. An antique map and compass add additional nautical touches.

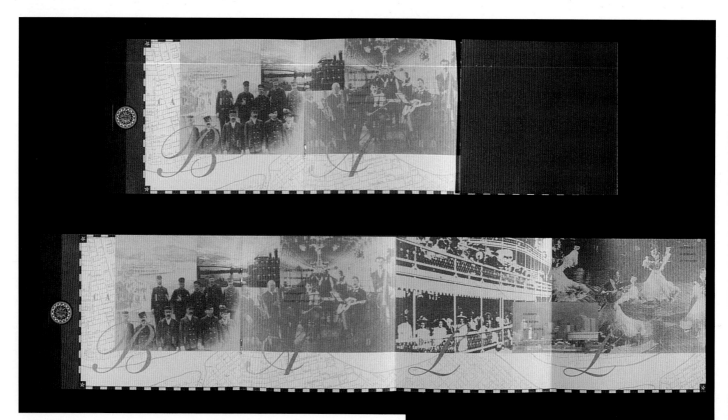

Design by Kolar Design, Inc.
Designers: Kelly Kolar, Deborah Vatter, Vicky Zwissler

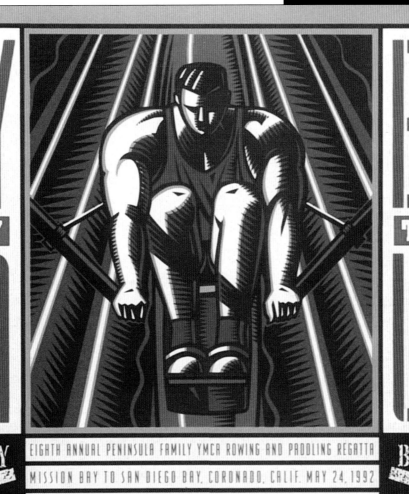

Design by Mires Design, Inc.
Art Director/Designer: José Serrano

A woodcut illustration in the muscular WPA style is the
centerpiece of this rowing regatta announcement. The
elongated letters used in the title reflect long rowing oars.

**Christmas card for Rickabaugh Graphics**

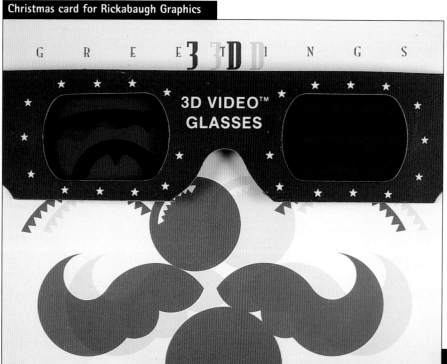

3D VIDEO™
GLASSES

Design by Rickabaugh Graphics
Designer: Mark Krumel
Illustrator: Tony Meuser

Hoping to raise the spirits of its clients,

Rickabaugh Graphics mailed a 3-D holiday card,

complete with special glasses. In boldface type

the studio reveals the three *D*s it wishes for the

season: "dazzling," "delightful," and "delicious."

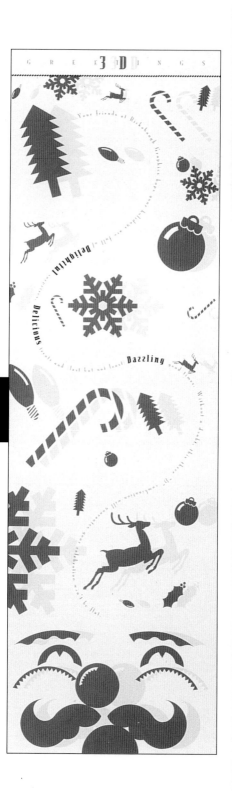

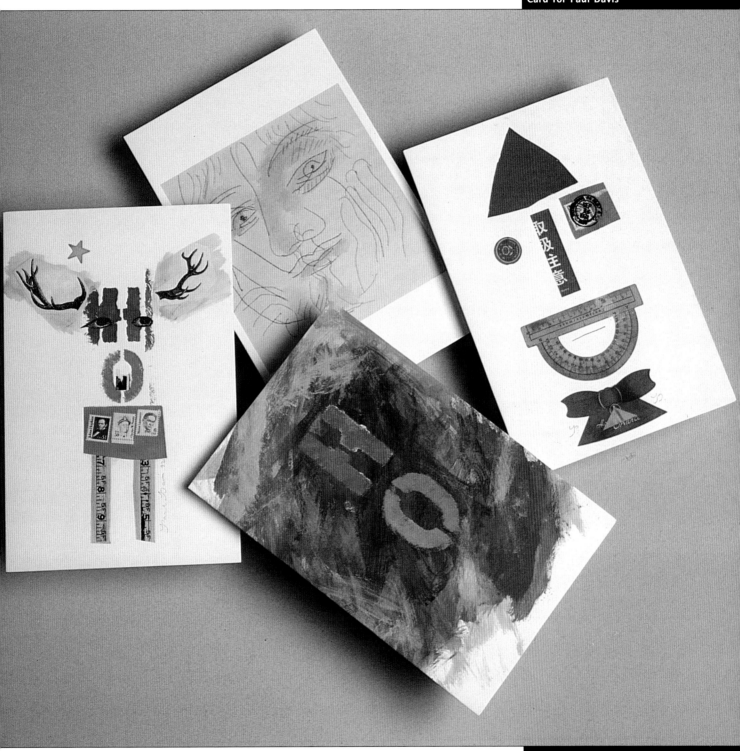

Design by Paul Davis Studio
Designer: Paul Davis

Paul Davis' distinctive illustration style is revealed in four holiday
cards that display his understated humor and interest in myriad
techniques and media, including collage, painting, and pastels.

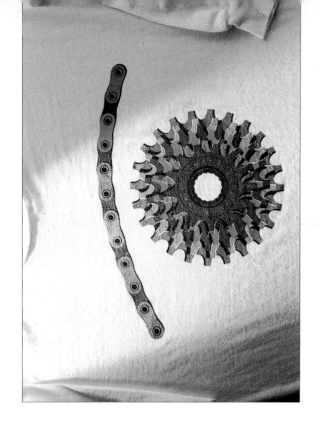

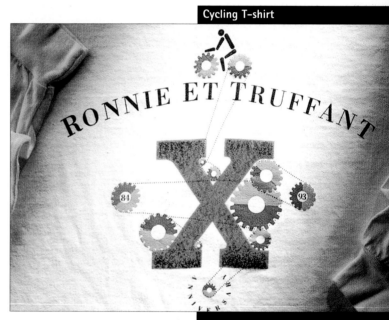

Design by Hornall Anderson Design Works
Art Director: Jack Anderson
Designer: Julie Keenan
Illustrators: Julie Keenan, John Anicker

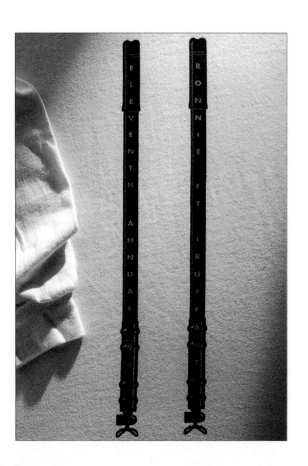

To commemorate the tenth anniversary of a cycling event, a T-shirt with a motif based on cycling mechanisms was created: The number *10* is fashioned from multicolored gears and a section of chain in one example, while gears provide a decorative element on another. For the following year, the number *11* was represneted with bicycle pumps.

The unrefined lettering, imperfect color trapping, and overall cut-and-paste appearance of this layout helps create an edgy look for a snowboard client marketing to young adults.

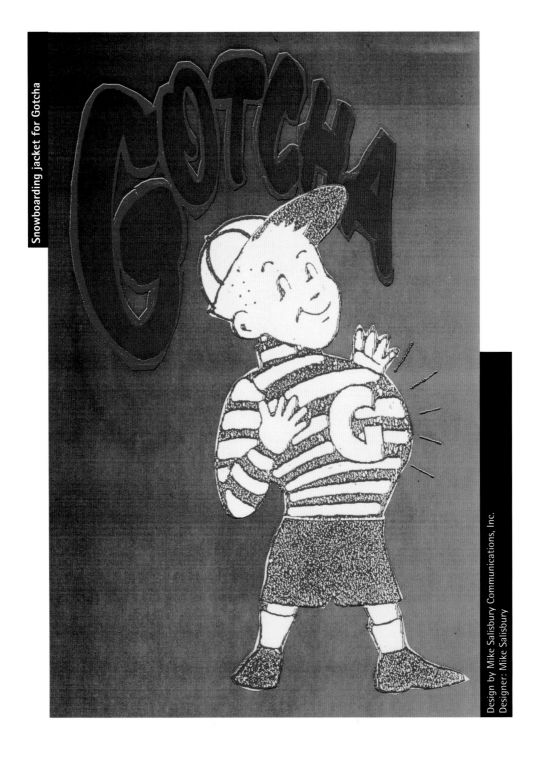

Snowboarding jacket for Gotcha

Design by Mike Salisbury Communications, Inc.
Designer: Mike Salisbury

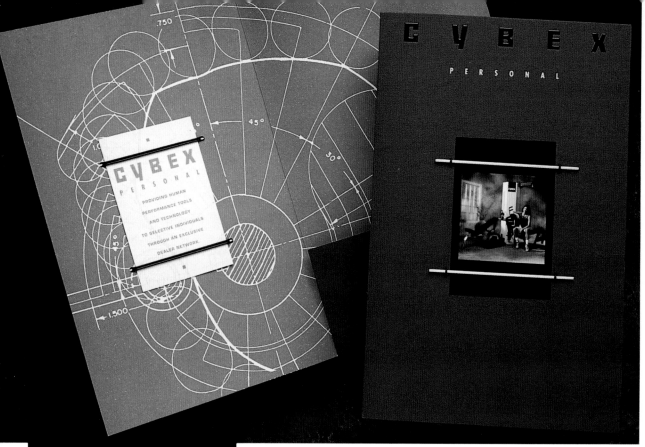

**Catalog for Cybex**

Strength, performance, and beauty are emphasized in this catalog for fitness equipment. The parallel bars framing the cover image symbolize barbells, and an architectural drawing inside demonstrates the trajectory of the weight machines. Painterly images of fine physiques attest to the product's effectiveness.

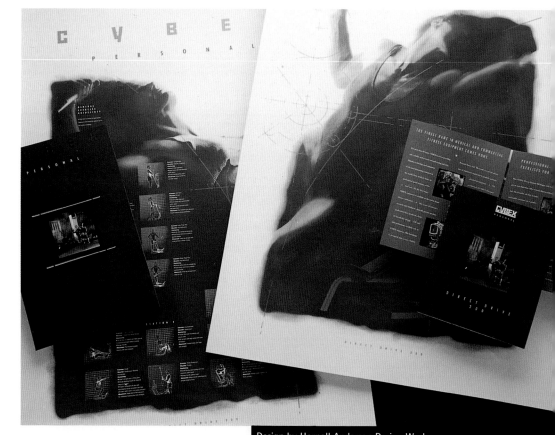

Design by Hornall Anderson Design Works
Art Director: Jack Anderson
Designers: Jack Anderson, David Bates, Jeff McClard, Julie Keenan

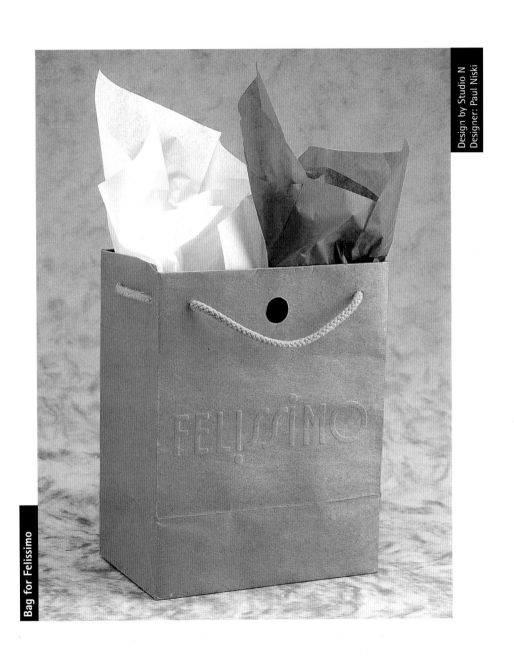

Design by Studio N
Designer: Paul Niski

**Bag for Felissimo**

To promote Felissimo, an eclectic upscale New York department
store, Studio N designed an understated shopping bag with sturdy
rope handles and an embossed store logo with a flopped letter *l*.

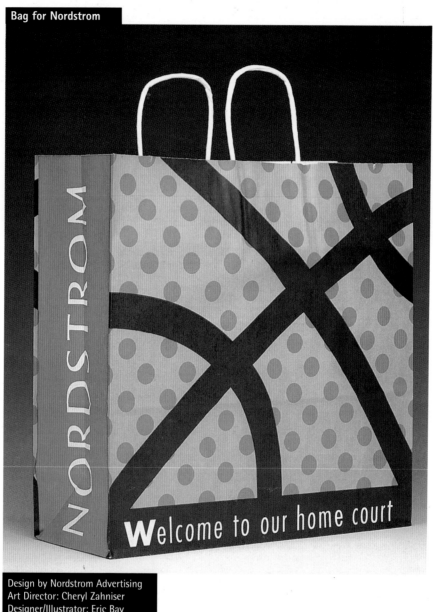

**Bag for Nordstrom**

Design by Nordstrom Advertising
Art Director: Cheryl Zahniser
Designer/Illustrator: Eric Bay

To illustrate an in-store promotion for the National Collegiate Athletic Association's Final Four basketball tournament, Nordstrom Advertising produced a shopping bag with an upbeat, abstract design based on a close-up perspective of a basketball's seams.

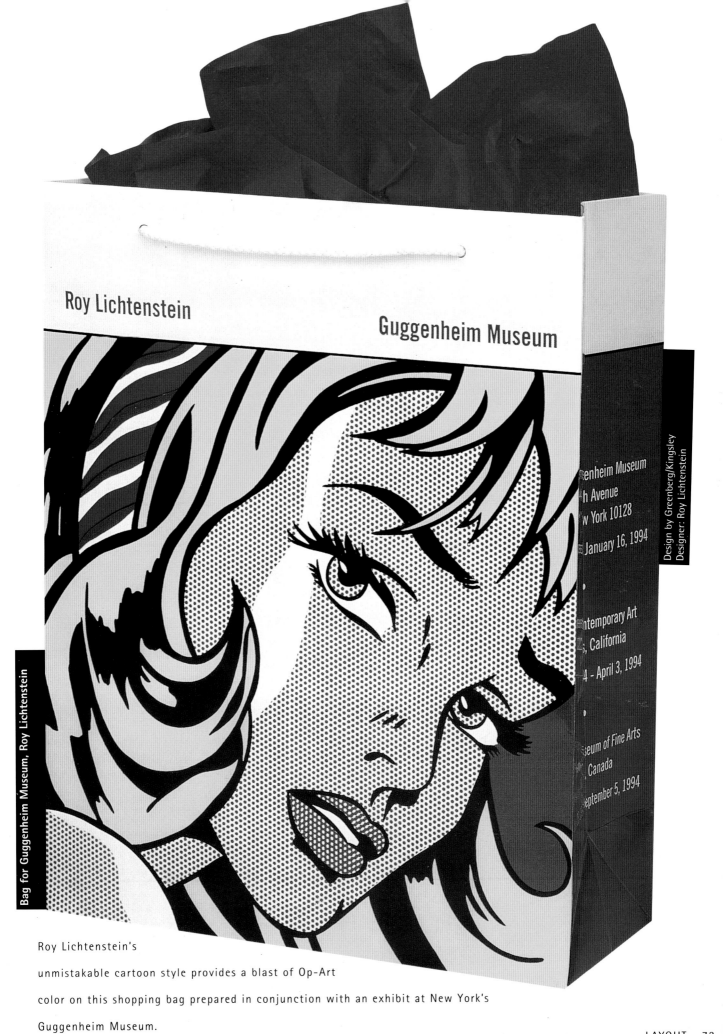

**Roy Lichtenstein**

**Guggenheim Museum**

Design by Greenberg/Kingsley
Designer: Roy Lichtenstein

...enheim Museum
...h Avenue
...w York 10128
... January 16, 1994

...ntemporary Art
..., California
...4 - April 3, 1994

...seum of Fine Arts
... Canada
...eptember 5, 1994

Bag for Guggenheim Museum, Roy Lichtenstein

Roy Lichtenstein's

unmistakable cartoon style provides a blast of Op-Art

color on this shopping bag prepared in conjunction with an exhibit at New York's

Guggenheim Museum.

The trompe l'oeil relief of parcels
appearing on bags for Le Central adds a
winsomely subtle counterpoint to the
sophisticated logo design on the flip side.

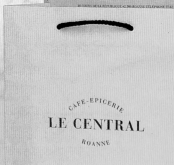

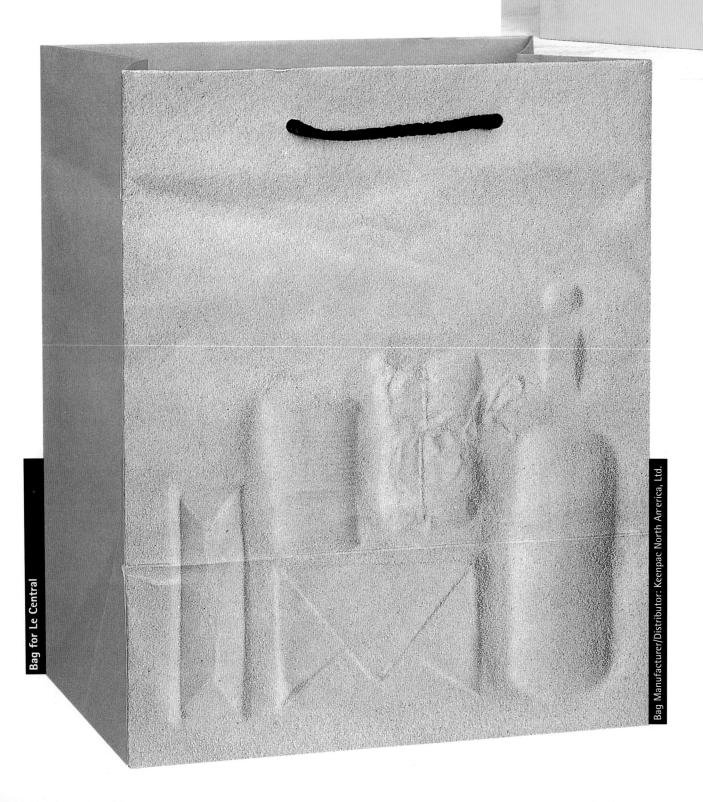

Bag for Le Central

Bag Manufacturer/Distributor: Keenpac North Arrerica, Ltd.

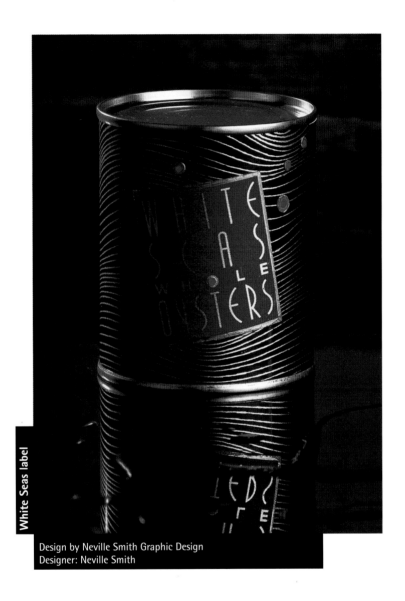

Design by Neville Smith Graphic Design
Designer: Neville Smith

The waves on these labels for gourmet canned oysters bring out

the product's fresh qualities, while touches of royal red, purple,

and gold give the packaging an upscale image.

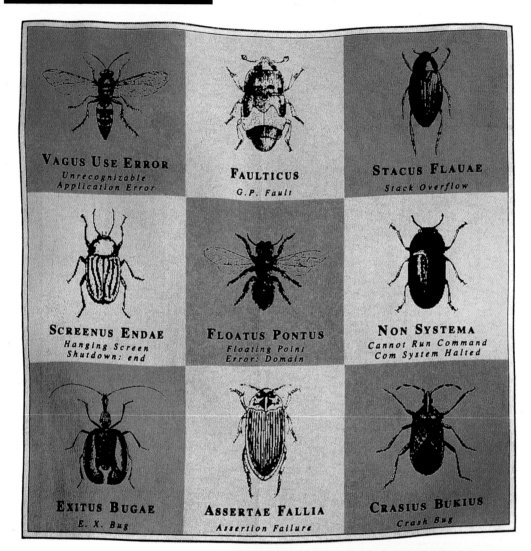

Design by Charney Design
Designer: Carol Inez Charney

T-shirts created for beta testers of C++ spoof the many forms of computer bugs with images of insects and humorously fake Latin names relating to software errors.

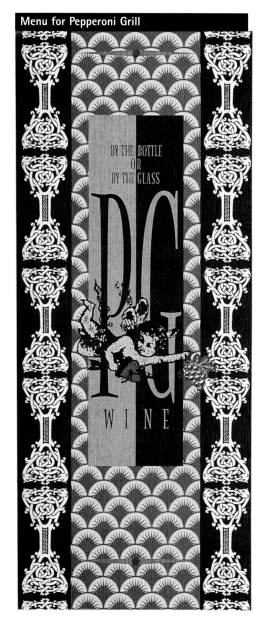

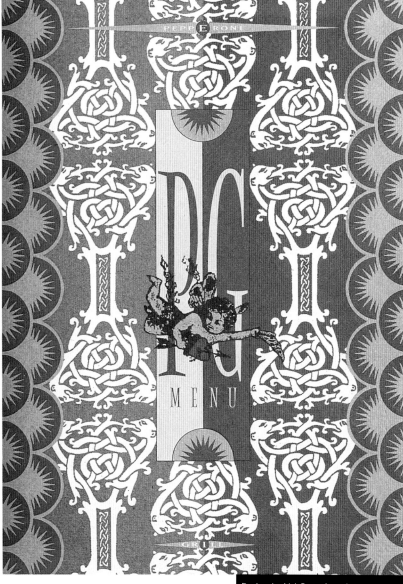

This menu design for the Pepperoni Grill is a delicious exercise in baroque excess, with cupids and highly ornamental patterns in jewel tones. The tall, condensed restaurant logo adds a contemporary touch.

APPETIZERS     PIZZA     PASTA     GRILL

**CROSTINI**
Chicken, tomato, basil and chevre.
4.95

**GARLIC FRIED CALAMARI**
Roma tomato sauce and Parmesan.
5.45

**BRUSCHETTA**
Toasted garlic bread with tomato-basil topping.
3.95

**FOCACCIA**
Brick-oven baked pizza bread with mozzarella, red onion and basil.
3.95

**SAUTÉED MUSHROOMS**
Soft polenta and mascarpone.
4.25

**FRIED MOZZARELLA**
With roma tomato sauce.
4.95

**TODAY'S SOUP**

**Salads**

**PEPPERONI SALAD**
Gorgonzola cheese, calamata olives, cucumbers, pepperoni, tomatoes, Dijon vinaigrette and basil.
6.95

**GRILLED CHICKEN SALAD**
Chilled asparagus, basil aioli, cashews, seasonal greens and fried polenta.
7.95

**PESTO MARINATED CHICKEN SALAD**
Mixed greens, tomato, mozzarella, basil, red onion, olive oil and balsamic vinegar.
8.25

**CAESAR SALAD**
5.95

**CHICKEN CAESAR SALAD**
7.45

**DINNER CAESAR**
3.95

**SEASONAL GREENS**
With baked chevre.
4.50

**BASIL**
Roma tomatoes, fresh mozzarella and fresh basil.
5.95

**HERB SAUSAGE**
Grilled zucchini and roma tomatoes.
6.25

**CANADIAN BACON**
Fresh pineapple and pine nuts.
6.95

**PEPPERONI**
Sun-dried tomatoes, pepperoni and Italian parsley.
6.95

**ROASTED VEGETABLE**
Chevre, pine nuts and fresh herbs.
6.75

**GRILLED EGGPLANT**
Tomato sauce and fresh basil.
6.75

**MUSHROOM**
Gorgonzola and tarragon.
6.95

**PROSCIUTTO**
Braised radicchio, onion and Italian parsley.
6.95

**SHRIMP AND PESTO**
Asparagus and Italian parsley.
7.95

**SAUSAGE CALZONE**
Five cheeses, Italian sausage, basil and roma tomato sauce.
6.95

**TODAY'S PIZZA**
Market

**SPAGHETTINI**
With tomato, basil, garlic, Parmesan and olive oil.
6.25

**CAPPELLINI PRIMAVERA**
Fresh vegetables, olive oil and garlic.
6.50

**FETTUCCINI**
With veal bolognese sauce.
7.95

**PAPPARDELLE**
Shrimp and lemon cream.
8.95

**RIGATONI**
Chicken, broccoli and roma tomato sauce.
7.95

**FETTUCCINI ALFREDO**
Classically prepared.   7.95
With grilled chicken.   9.95
With sautéed shrimp.   10.95

**TORTELLINI**
Cheese-filled, tri-colored pasta, with pesto cream and tomato-basil garnish.
9.75

**VEGETABLE LASAGNA**
Spinach pasta, ricotta, Parmesan, mozzarella, spinach, vegetables and tomato sauce.
8.50

**MEAT LASAGNA**
Italian sausage, ricotta, mozzarella, Parmesan and tomato sauce.
8.95

**PENNE**
Roma tomato sauce, Italian sausage, parsley and Parmesan.
6.95

**MANICOTTI**
Egg pasta, ricotta, Parmesan, mozzarella and roma tomato sauce.
8.75

**CANNELLONI**
Spinach pasta, chicken, mushrooms, eggplant, tarragon, roma tomato sauce and melted mozzarella.
8.95

**ITALIAN SANDWICH**
Salami, ham, bologna, olive salad with fried potatoes.
6.95

**ROTISSERIE HALF CHICKEN**
Garlic, rosemary, mashed potatoes and wilted spinach salad.
8.25

**CHEESEBURGER**
Fontina and fried potatoes.
5.95

**GRILLED STRIP SIRLOIN**
Soft polenta and mushrooms.
13.95

**EGGPLANT SANDWICH**
Tomatoes, olives, chevre, mozzarella, caper mayonnaise, olive salad, fried potatoes.
6.95

**VEAL MARSALA**
On fettuccine with sun-dried tomato and mushrooms.
12.95

**EGGPLANT PARMESAN**
Fettuccini Alfredo, tomato, mozzarella and Parmesan.
8.95

**GRILLED SALMON**
Tomato, onion, creamy polenta and basil penne.
12.95

**GRILLED PORK CHOP**
With sun-dried tomato vinaigrette, mashed potatoes and vegetables.
11.95

**CHICKEN ALFREDO SANDWICH**
Pepperoni, sun-dried tomatoes, fresh parsley, Alfredo sauce, grilled chicken breast and spring vegetables.
7.25

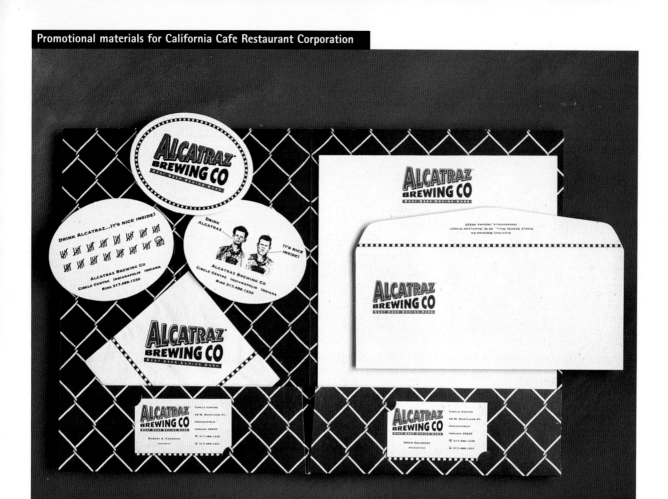

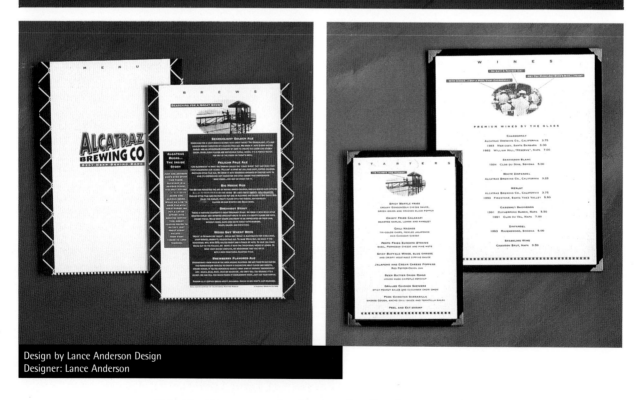

Design by Lance Anderson Design
Designer: Lance Anderson

This identity program for Alcatraz Brewing Company raises a frosty mug to the fabled island jail with a chain-link fence motif accenting folders and menus. The skewed perspective of the three-dimensional logo lettering pays tribute to a 1950s prison escape movie.

Design by Louise Fili Ltd.
Designer: Louise Fili

**Stationery for Candle Cafe**

The freshness of the food served at the Candle Cafe is emphasized

in print pieces illustrated with highly detailed images from a

vintage seed catalog.

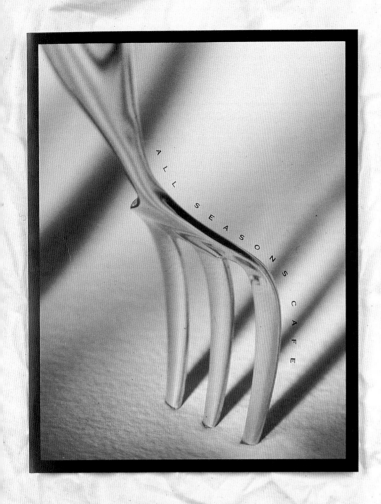

ALL SEASONS CAFE

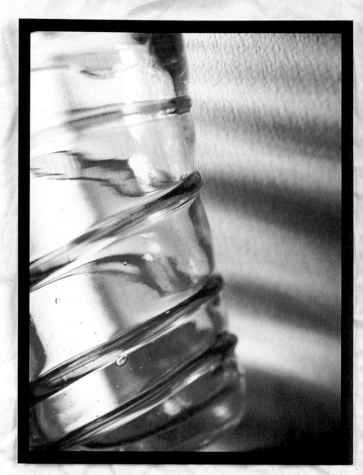

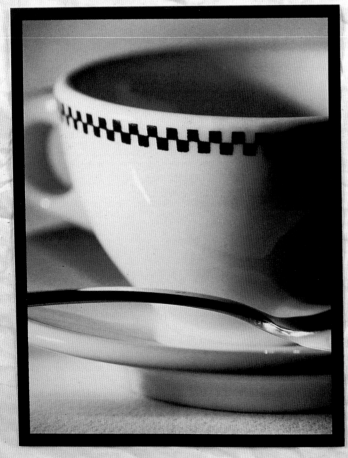

The spirit of the wild west stampedes across this menu design for the Disney-operated Crockett's Tavern, with its wood-grain cover, background images of hunting and exploring and touches of leather and wood. A paper coonskin cap completes the childhood fantasy.

**Menu for Crockett's Tavern**

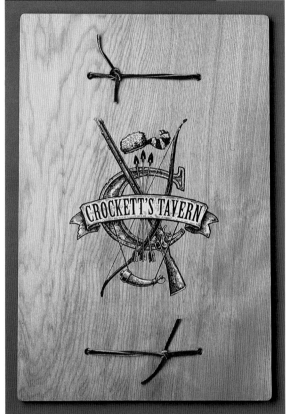

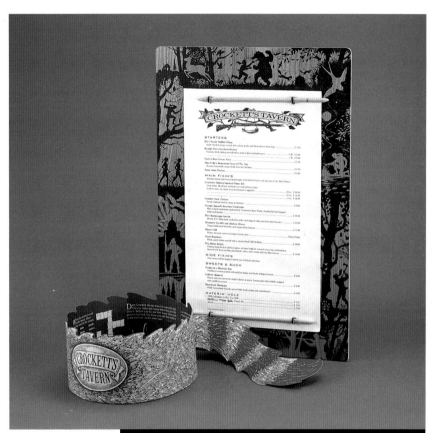

Design by Disney Design Group
Art Directors: Jeff Morris, Renée Schneider
Designers: Thomas Scott, Michael Mohjer
Illustrator: Michael Mohjer

**Menu for Hyatt Hotels Corp.**

Menus for the All Seasons Cafe, with their pure, sensuous photographic images of the dining experience, convey a casual urban chic.

sign by Associates Design
t Director: Chuck Polonsky
signer: Jill Arena
otographer: Dave Slavinski
mputer Artist: John Arena

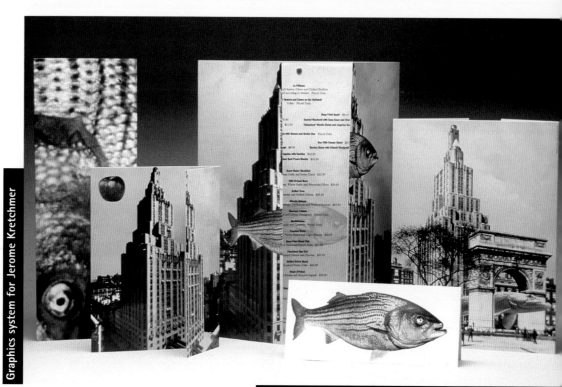

Graphics system for Jerome Kretchmer

Design by Pentagram Design
Art Directors: Paula Scher, James Biber
Designer: Ron Louie
Photographer: Peter Mauss/Esto

ONE

FIFTH

AVENUE

NEW

YORK,

NY

10003

(212)

529-1515

Paula Scher reels in a touch of surrealism in graphics for One Fifth, a New York seafood restaurant. On the menu, a sepia-toned fish looms under the Washington Square Arch, and again above a skyscraper like a Macy's parade balloon.

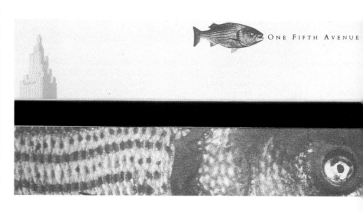

ONE FIFTH AVENUE

One glance at these menus for Cathay Pacific assures that no one will be offered Salisbury steak in a foil container. Watercolor images with Asian overtones appear on the cover with widely tracked lettering with a touch of a calligraphic brushstroke, creating a gentle East-meets-West feeling.

Design by PPA Design, Ltd.
Art Director/Designer: Byron Jacobs

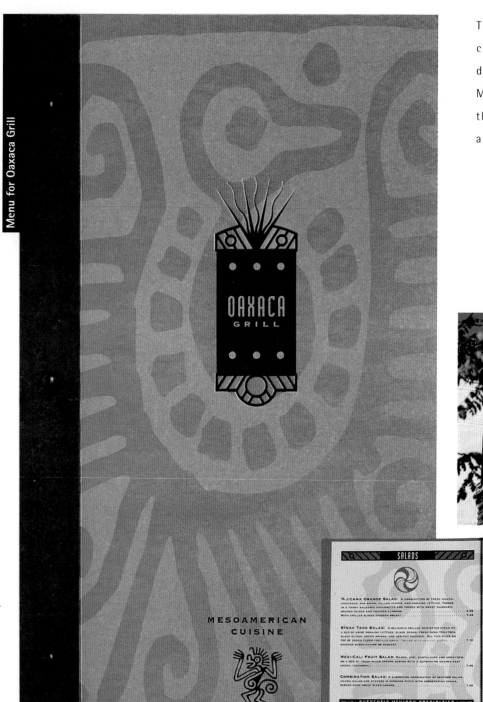

The graphic influence of this Mexican city are unmistakable in the menu design and signage for this Mesoamerican restaurant which, with the red clay color scheme creates an aura of authenticity.

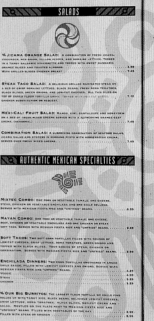

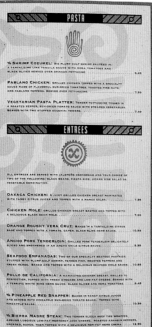

Design by Greteman Group
Art Director: Sonia Greteman
Designers: Sonia Greteman, Jo Quillin, Chris Parks

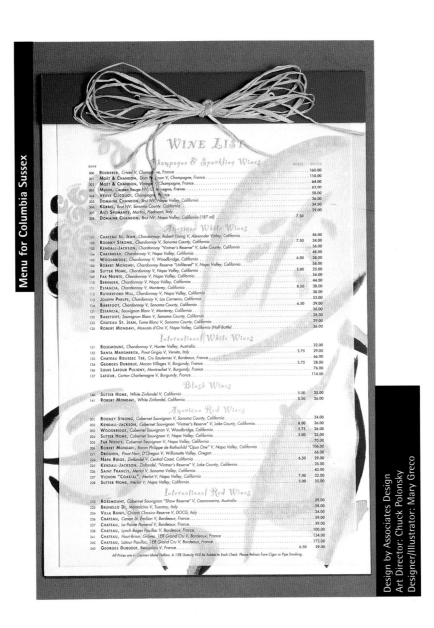

Design by Associates Design
Art Director: Chuck Polonsky
Designer/Illustrator: Mary Greco

A wine list printed on translucent paper and placed over large, wine-related watercolor images whets the appetite while lightening up text-heavy page.

Identity system for Tony Goldman

GREENE STREET

Design by Sagmeister, Inc.
Art Director/Designer: Stefan Sagmeister

A table fork and a tuning fork simply and

humorously convey the food and musical offerings at

Greene Street, a SoHo cafe.

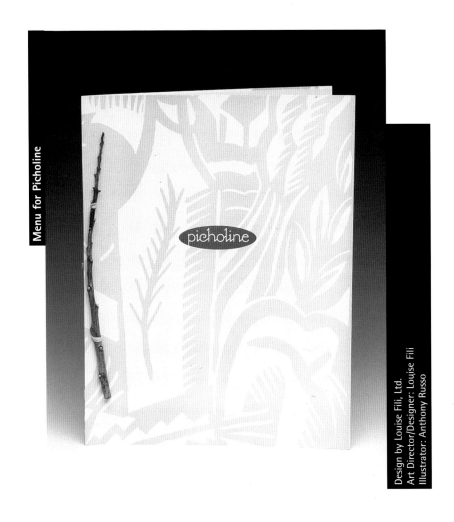

**Menu for Picholine**

Design by Louise Fili, Ltd.
Art Director/Designer: Louise Fili
Illustrator: Anthony Russo

A woodcut illustration of earthy images in soft tones graces the cover of this menu for Picholine. The subtlety is also apparent in the choice of a 1920s Art Deco script for the restaurant's logo.

The appearance of circular shapes is a graphic continuum in this menu's design for the Eagle's Nest restaurant, appearing as phases of the moon, as champagne bubbles, or in a cluster of grapes.

**Menu for Eagle's Nest**

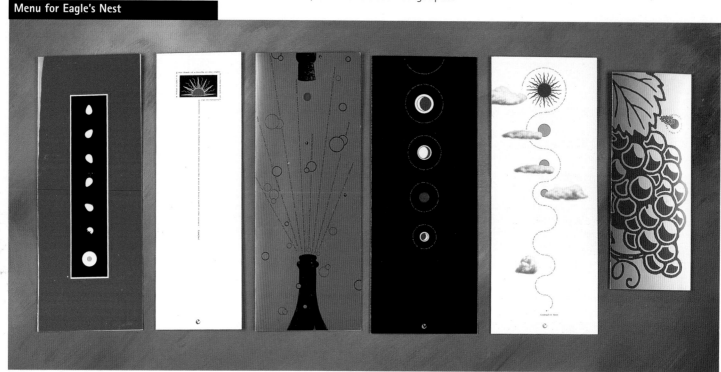

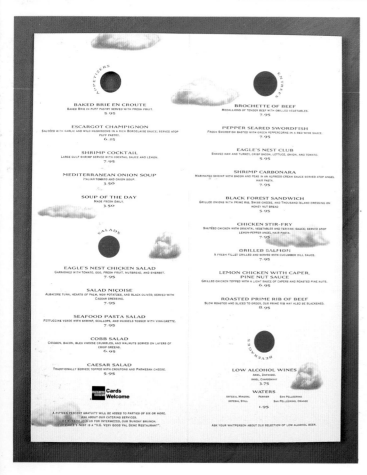

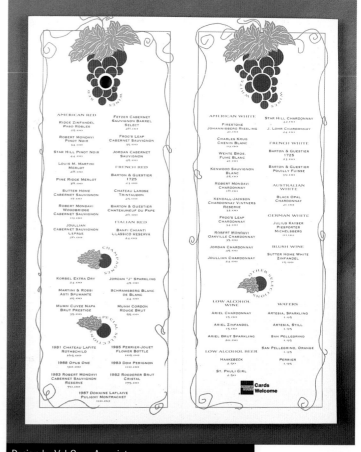

Design by Val Gene Associates
Art Director/Designer: Lacy Leverett
Production: Shirley Morrow
Photographer: Chuck Doswell III

[metal] **Studio Inc.** 1210 W.Clay Suite 13 Houston TX 77019  713.523.5177

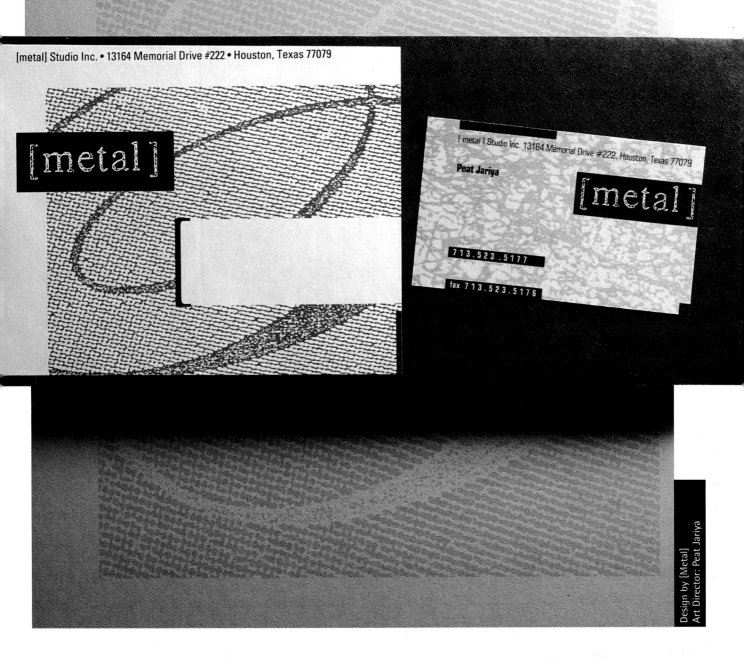

[metal] Studio Inc. • 13164 Memorial Drive #222 • Houston, Texas 77079

Design by [Metal]
Art Director: Peat Jariya

Art director Peat Jariya created an identity program with an industrial look for Metal studio

with distressed letters in the logo and screened calligraphic letters printed in metallic ink.

SAGMEISTER INC.

NEW YORK

SAGMEISTER INC.

222 WEST 14th STREET NEW YORK NY 10011 US of A TEL (212) 647 1789 FAX (212) 647 1788

Design by Sagmeister, Inc.
Art Director/Designer: Stefan Sagmeister

Stefan Sagmeister's signature style is creating

designs with optical illusions. He conveys that

in his stationery with a layered logo that

appears to be three dimensional.

An identity program for John Wong Photography uses long horizontal and vertical bars for type that subtly evoke strips of photographic film. The image of a man peering through a camera lens puts the emphasis on the photographer's eye.

Design by Peterson & Company
Art Director/Designer Bryan L. Peterson

JOHN
WONG
PHOTOGRAPHY

JOHN
WONG
PHOTOGRAPHY

2105 COMMERCE ST. FLOOR 2

DALLAS, TEXAS 75201

JOHN
WONG
PHOTOGRAPHY

2105 COMMERCE ST. FLOOR 2

DALLAS, TEXAS 75201

PH (214) 748 2323 FAX 748 0959

2105 COMMERCE ST. FLOOR 2

DALLAS, TEXAS 75201

PH (214) 748 2323 FAX 748 0959

Letterhead and logo design for John Wong Photography

Cooper-Hewitt

National **Design** Museum

Smithsonian Institution

2 EAST 91 STREET  NEW YORK NY 10128-0669 | TEL 212 860 6868 | FAX 212 860 6909

Design by Drenttel Doyle Partners
Art Director: Stephen Doyle
Designers: Terry Mastin, Rosemarie Turk

This identity program for the National Design
Museum has a contemporary look with sans
serif type that emphasizes the museum's focus.

**Adele Bass & Company** 55
758 E. Colorado Boulevard
Suite 209
Pasadena, CA 91101

**Alan Chan Design Company** 29, 30
2/F Shiu Lam Building
23 Luard Road
Wanchai, Hong Kong

**Alexander Isley Design** 34, 54
361 Broadway
Suite 111
New York, NY 10013

**Associates Design** 80, 85
3177 MacArthur Boulevard
Northbrook, IL 60062

**Aufuldish & Warinner** 49
183 The Alameda
San Anselmo, CA 94960

**BRD Design** 16–17
6525 Sunset Boulevard
6th Floor
Hollywood, CA 90028

**Carmichael Lynch** 10
800 Hennepin Avenue
Minneapolis, MN 55403

**Carre Noir** 27
Rue Des Mimosas 44
B-1030 Brussels
Belgium

**Charney Design** 76
1120 Whitewater Cove
Santa Cruz, CA 95062

**Clifford Selbert Design** 53
2067 Massachusetts Avenue
Cambridge, MA 02140

**CopperLeaf** 50
364 West 1st Avenue
Columbus, OH 43201

**COY** 19
9520 Jefferson Boulevard
Culver City, CA 90232

**Diana Howard Design** 11
2025 Stockton # 4
San Francisco, CA 94133

**Disney Design Group** 81
Walt Disney World
P. O. Box 10,000
Lake Buena Vista, FL 32830-1000

**Drenttel Doyle Partners** 92
1123 Broadway
New York, NY 10010

**ECCO Media** 47
89 Fifth Avenue
New York, NY 10003

**eyeOTA in-house design** 26, 37
541 Lillian Way
Los Angeles, CA 90004

**Graffito/Active8** 45
601 North Eutaw Street
Suite 704
Baltimore, MD 21201

**Greteman Group** 84
142 North Mosley
Wichita, KS 67202

**Herman Miller in-house design team** 12
855 E. Main Street
Zeeland, MI 49464-0300

**Hoffman and Angelic Design** 23
317-1675 Martin Drive
White Rock, BC V4E 6E2
Canada

**Hornall Anderson Design Works** 24, 28, 68, 70
1008 Western Avenue
Suite 600
Seattle, WA 98104

Human Code, Inc. 51
1411 West Avenue
Suite 100
Austin, TX 78701

Ida Cheinman, Rick Salzman 57
P. O. Box 1825
Plattsburgh, NY 12901-0260

Independent Project Press 60
Box 1033
Sedona, AZ 86339

Kiyoshi Kanai, Inc. 39
115 East 30th Street
New York, NY 10016

Kolar Design, Inc. 64
308 E. 8th Street
5th Floor
Cincinnati, OH 45202

Lance Anderson Design 78
22 Margrave Place
Studio 5
San Francisco, CA 94133

Laughlin, Winkler, Inc. 58
4 Claredon Street
Boston, MA 02116

Louise Fili, Ltd 79, 87
7 West 16th Street
New York, NY 10011

Margo Chase Design 14, 15
2255 Bancroft Avenue
Los Angeles, CA 90039

Maureen Erbe Design 21
1948 South La Cienega Boulevard
Los Angeles, CA 90034

[Metal] 89
1210 West Clay
Suite 13
Houston, TX 77019

Michael Stanard, Inc. 62
1000 Main St.
Evanston, IL 60202

Mike Salisbury Communications 6, 7, 22, 36, 69
2200 Amapola Court
Torrance, CA 90501

Mires Design, Inc. 8, 13, 63, 65
2345 Kettner Boulevard
San Diego, CA 92101

Morla Design 52
463 Bryant Street
San Francisco, CA 94107

Muller + Company 41, 61
4739 Belleview
Kansas City, MO 64112

Neville Smith Graphic Design 75
131 Mayburry, Skyridge
Aylmer, QB J9HSE1
Canada

Paul Davis Studio 67
14 East 4th Street
New York, NY 10012

Pentagram Design 32, 33, 82
204 Fifth Avenue
New York, NY 10010

Peterson & Company 91
2200 N. Lamar
Suite 310
Dallas, TX 75202

Petrick Design 35
828 North Wolcott Avenue
Chicago, IL 60622

PPA Design, Ltd 83
69 Wyndham Street
7/F, Central
Hong Kong

**Primo Angeli** 48
590 Folsom Street
San Francisco, CA 94105

**Red Dot Interactive** 46
87 Stillman Street
San Francisco, CA 94107

**Rickabaugh Graphics** 66
384 W. Johns Towns Rd
Gahanna, OH 43203

**Sagmeister, Inc.** 42, 43, 44, 86, 90
222 West 14th Street, # 15A
New York, NY 10011

**Sayles Graphic Design** 38, 56
308 Eighth Street
San Francisco, CA 94115

**Shimokochi/Reeves** 59
4465 Wilshire Boulevard
Suite 305
Los Angeles, CA 90010

**Sibley/Peteet** 9, 38, 39
3232 McKinney #1200
Dallas, TX 75204

**Stewart Monderer Design, Inc.** 25
10 Thacker Street # 112
Boston, MA 02113

**The Bang** 20
618 Logan Avenue
Toronto, ON M4K3C3
Canada

**Trickett & Webb** 18
The Factory
84 Marchmont Street
London WC1N 1HE
England

**Val Gene Associates** 77, 88
5208 Classen Boulevard
Oklahoma City, OK 73118